YOU CAN DO IT!

A GUIDE FOR THE ADULT LEARNER

AND ANYONE GOING BACK TO SCHOOL MID-CAREER

Harry G. Turner

You Can Do It!
A Guide for the Adult Learner
and Anyone Going Back to School Mid-Career

First edition, 1997
Copyright © 1997 Merritt Publishing and Merritt
Professional Publishing, divisions of The Merritt
Company

Merritt Publishing
Merritt Professional Publishing
1661 Ninth Street
P.O. Box 955
Santa Monica, California 90406

For a list of other publications or for more information
from Merritt Publishing, please call (800) 638-7597.

Library of Congress Catalog Number Pending

Turner, Harry G.
You Can Do It!
A Guide for the Adult Learner
and Anyone Going Back to School Mid-Career

Includes index.
Pages: 232

ISBN: 1-56343-153-X
Printed in the United States of America.

Table of Contents

- Don't Filibuster!
- Summary

- Reading Skills
- Listening Skills
- Note Taking
- Math Skills
- Memory Skills
- Test-Taking Skills
- True or False
- Multiple Choice Exam
- Duration of Your Trip

"It's a shame. Youth is wasted on the young!"

There is a lot of wisdom in this saying. How many times have we lamented, "Oh, to be young again!" Often, these words are uttered with regard to physical strength and stamina. But think back to your youth. Not only were you stronger, more agile and quicker, but you also seemed "smarter."

Perhaps you were a quick learner and you possessed a fabulous memory. Now it seems that you have to write everything down or leave yourself notes if you need to remember something. And even then, you might forget where you put the note. Has it ever happened that someone asks for your home phone number or address and you hesitate to respond because you just "drew a blank"?

Fear not. You are not getting dumber with age. You're probably nearly as intelligent as you were when you were 16 years old. If you believe in the validity of the Intelligence Quotient (IQ) as a measurement of intelligence, you'll be glad to know your IQ only fluctuates a few points over your entire adult life.

Two things probably have happened to you, though. First of all, your life is much more complex today than it was when you were a teenager. Chances are your mind is bombarded with issues, such as your

family, your career, the family budget, a major financial expenditure like a new home, etc. With your mind and memory overloaded with thoughts, ideas, impulses and stimuli, the task of remembering becomes more complex.

The second thing that probably has happened to you is you stopped learning a long time ago—possibly when your formal education ended. You're really not "losing it." You're simply a bit rusty. Your ability to learn and master new skills is still there; you just have to restart your learning engine.

It's like a broken arm. If your arm has been in a cast for the past six weeks and has been absolutely no use to you, and today the cast is coming off, you'll find that your arm has "forgotten" how to function, simply because it has been inactive for so long. The muscles will have to be retrained or reprogrammed if you are to regain full use of your arm. We refer to this as physical rehabilitation.

As an adult, you have to rehabilitate your mind and sharpen your skills, so that learning is as easy as it was when you were young and your mind seemed like a sponge, literally soaking up every bit of information and knowledge that was available to you.

Learning begins at birth (if not before) and ideally should continue throughout life. In the business environment, it is essential that learning be a lifelong activity. New skills and knowledge will provide you with a competitive advantage over your peers. The ability to learn may be the key to economic survival—and job security.

In these times of reengineering, downsizing, merg-

ers, reorganizations, etc., we are all pressured to learn new skills and adapt to new work situations. Job security as we've known it may be a thing of the past. Any form of job security today must be based on what we know and how much we can learn.

The purpose of this book is to rescue your minds and learning abilities from the bottomless pit of atrophy. Webster's defines *atrophy* as "a wasting away or the failure of an organ or part to grow or develop because of insufficient nutrition." Our learning ability and skills will waste away if they are not nourished by new challenges, training and educational activity.

This book is designed to provide you with the necessary nourishment to sharpen your learning skills and thus facilitate the learning process, and at the same time enable you to acquire some insight into the behavior and characteristics of the adult learner. We will focus on improving your reading and comprehension, listening, writing, math and study skills, and will provide guidance on test-taking techniques. We also address the appropriate learning environment for you, and how to maintain enthusiasm and a positive attitude toward learning.

The Adult Learner

You are what you are today primarily because of learned behavior. You may be tall or short, have blue eyes or brown, be male or female—these are inherited traits. But our personalities are generally formed from what we've learned from our environment.

Most of your non-physical characteristics are the result of learning, which takes place in your environment. At an early age, you learned how to walk by trial and error. You learned how to talk by listening, repeating and remembering words. You began your formal education in elementary school, went on to high school and possibly college. During your formal education years, you learned various social, functional and job-related skills.

Finally, you were ready for the working world. Your formal education was complete, your skills were developed, and you had something to offer a prospective employer. You landed your first job and then, except for some brief, infrequent company training programs, learning stopped.

This scenario has been played out countless times in our work force. It is partly based on what might be labeled the "old employment contract." Generally, the belief was that once you got a job, became a reliable

The Old and the New Employment Contract

and productive employee, played the corporate game and did what had to be done, you would have job security until retirement. It was a very paternalistic situation. The employer would take care of you, and unless the employer stipulated that you had to learn some new skill, generally you stopped learning. Your learning skills and abilities began to atrophy.

However, for the most part, the old employment contract has gone the way of the dinosaur. In the working world today, we must deal with the **new employment contract**. The new contract does away with paternalism and, generally, job security as well.

In accordance with the terms of the new contract, the worker is a commodity, an asset. As a business asset, a profit must be realized. If the asset is profitable, then it remains a business asset. However, if or when the asset becomes obsolete, it will be discarded and replaced. The process of replacing the obsolete has many names—restructuring, reorganization, downsizing, reengineering, etc.

Thus, there is no longer an implied lifetime employment contract. The new employment contract may have a life of five years, ten years or longer, but whenever unprofitability sets in, assets (personnel) will be restructured so that the business can again operate profitably. Paternalism and long-term loyalty no longer can be counted on.

How can you survive in this work environment? You must become more valuable to your employer so that you can stay one step ahead of the reengineering ax. Learning new skills and continuing your education can serve as your principal defense against a short-term employment relationship.

Once this realization hits a person who has been out of the learning mode for many years, despair and depression can set in. The challenge of learning new things after possibly 10 or 20 years of non-learning can be very frustrating. You haven't been using your learning skills, and you have to prep the engine, oil the parts and restart the learning machine by rejuvenating or resurrecting the skills and abilities of your youth.

As a child, you were constantly exploring your environment, discovering and learning new things, actively seeking learning opportunities, such as having an adult read you a book, learning how to walk, learning to turn on the TV, finding your favorite cartoons and asking that universal question—"Why?" Your mind was a sponge, soaking up everything *without* a formal teacher or classroom situation.

Becoming a Sponge Again

You were an **aggressive learner**. You didn't wait; you couldn't wait for a formal presentation from a teacher. For example, you learned how to speak one of the more difficult languages, English, before you ever set foot in a classroom. One of the reasons you were so aggressive and eager to learn was that no one had yet instilled in you the fear of failure, nor had you ever been intimidated by having to take a test. You were totally uninhibited as a young child.

This enthusiasm for learning followed you to kindergarten and possibly up through the fourth or fifth grade. Then the dreaded disease known as adolescence set in, and you underwent some major physical and emotional changes that would forever change you as

an individual and a learner. You probably would never again be the aggressive learner that you were as a child.

You now became a **passive learner** as a young adult. Your aggressiveness turned into reaction. Seldom did you seek out new learning activities. You now waited for a teacher to instruct you, assign homework, administer tests and give you a grade, which was a measurement of what you had learned—or was it a measurement of what the teacher believed he or she had taught? Tests, grades and fear of failure now became your "motivation" for learning.

If you observe a preschool class or kindergarten class, you can see, feel and even sometimes smell various learning activities. Every 4- or 5-year-old has a question. The entire group is involved in learning how to paint, cook, work with numbers, etc. There is enthusiasm everywhere. The air is thick with learning excitement.

Now take a look at a typical class of high school juniors or seniors, or even a college classroom. What do you see? A teacher standing in front of the room and 20 or 30 blank expressions on the faces of the students. A certain quiet and even solitude persists in the room. A question is asked and two or three students raise their hands to answer (not the entire class). Those who don't raise their hands often fail to do so out of fear of providing an incorrect response that might make them look "dumb."

Some members of this young adult class spend much of their time watching the clock or looking out of the window. Possibly two or three of these students are actually taking a nap! What's even worse is that

the teacher seems to care less that these two or three are napping. After all, they can't cause any problems while they're sleeping.

There is no excitement, no enthusiasm. The young adult learner is a passive observer at best, not an involved, eager learner. Unfortunately, much of our formal education is spent in this type of environment.

Finally, we graduate—or escape—from this lethargic environment and get a job. Due to our negative learning experiences, we now breathe a sigh of relief with the belief that we're out; we're finished with learning and education.

Fortunately, the 4- or 5-year-old aggressive learner is still inside of us to some degree. For example, as an adult, you may eagerly and actively pursue tennis or golf as a recreational hobby. You look forward to a golf or tennis lesson. You participate and ask many questions. On your own initiative, you read books about golf or tennis, subscribe to magazines, spend long hours practicing your putting or your backhand. So the active, enthusiastic learner is still within us, given the proper motivation.

These are the traits and motivation needed to learn, whether the subject is how to operate a computer on the job or how to chip and putt on the golf course. The problem is that when we are placed in the classroom environment again, the old habits emerge. We tend to become passive, reactionary learners, instead of aggressive and enthusiastic ones as we are with the golf or tennis lesson.

In other words, it is possible to regain the excitement and fun of learning, instead of viewing learning

as a necessary evil. We can become sponges again. The formula for effective learning requires that we sharpen our learning skills, be enthusiastic about learning and have a positive attitude.

The
Learning
Challenge

> **Effective Learning =**
> **Skills + Enthusiasm + Attitude**

The necessary effective learning skills that we will explain and impart to you through this book include:

- Reading and comprehension skills

- Listening skills

- Writing skills

- Certain math skills

- Study skills

- Test-taking techniques

Not only is it important to be able to **read**, but equally important to **understand** what you are reading and what it means. Often, people read by simply scanning without a clear understanding of what it is they're actually reading. Once material is read, how well do you retain this information? The application of proper reading and comprehension skills naturally leads to more effective learning.

Most people can hear; not all people **listen**. Since much learning takes place through our auditory sense, it is critical that we be effective listeners. Again, this is especially important with regard to adults. Children

hear everything! It seems as we get older, not only may our hearing become physically impaired, but we also tend to listen less and less.

A mother may say to her young child, "Did you hear what I said?" In contrast, a boss may say to his subordinate, "Are you listening?" Often the employee replies, "Yes, I heard you." Did the employee listen in this case, or simply hear?

In terms of learning, **writing** skills involve both your ability to communicate with others and your ability to communicate with yourself through written notes you take from lectures or reading material. How effective are you at focusing on what is important in terms of note taking? How well do you communicate in writing with others?

Many of us are not **math** whizzes, and often there is no need for us to become mathematical experts. Nevertheless, math is a basic skill that can facilitate learning. For example, an individual who is caught up in a reorganization may search for a new career. Frequently, this new job will require a state license of some sort, which involves passing a written licensing exam, such as in real estate. Undoubtedly, this written exam will contain some basic math, and thus the individual will need to brush up on basic math skills as part of the learning process.

How do you **study**—whether in preparation for an exam or with respect to learning a new job-related skill? Are you a morning person or an afternoon person? Is your retention better before lunch or after lunch? Do you study best by listening, watching or reading? Proper study skills are necessary for any learning endeavor.

It seems no matter what we learn, someone requires that we take a **test** to prove that learning has taken place. Test taking is as old as learning and education itself. Tests may actually measure what the student has learned, or they may serve as a security blanket for the teacher as proof that the "message got through."

Adults, particularly those caught up in career changes, may find themselves taking interest tests, aptitude tests, skills tests, licensing exams, etc. How well did you take tests when you were 18 years old? How well do you take tests today at age 38 or 48? What are some of the "tricks of the trade" when taking exams?

These and other skill-related questions will be answered throughout this book.

Summary

Enthusiasm for the learning process has to be rekindled in the adult learner. Whether you are 24 or 54, you need to recapture the enthusiastic approach to learning that you had when you were 4. It has to come from within. You must want to learn because you recognize the importance of lifelong learning—and the fact that you will be a more well-rounded person because of learning.

This enthusiastic approach to learning is part of the positive attitude you also must have. Your attitude toward learning, whether for personal or occupational enhancement, must reflect your desire and motivation to learn. Learning should be perceived as a joy, not a task or burden. Attitude can make or break a person's chances for learning—and his or her career.

Thus, the challenge for the adult learner is to want to learn for the joy of learning. The challenge is to be

more like our 4-year-old, who attacks and devours learning for the simple joy and satisfaction of knowing and understanding. The challenge is to understand yourself, your skills and your learning abilities, so that you can improve yourself, your working skills and your life like a 4-year-old sponge!

2

How Do You Learn?

Do you know how you actually learn? Do you know which is the best learning method for you?

As an adult learner, it is important for you to understand how you learn best. As an adult, you will have choices about how information is presented—or when. And so you will need to determine which types of learning and which learning methods best suit your learning profile.

Identifying your learning profile and then making choices based on this knowledge should help make the learning process enjoyable again. Equally as important, understanding how you best learn will improve your retention and comprehension.

The following survey is designed to help identify your learning profile.

What Is Your Learning Profile?

Learning Profile Survey

Grab a notebook and a pen or pencil and record whether each of the following statements is true or false for you, to reflect how you feel you learn best. Answer each statement as it would apply or not apply to you as a general rule. (You'll probably want to devote a notebook—or a section in a notebook—to the

exercises in this book, so you can refer back to them at a later date.)

1. I learned more in physical education class than I did in history class.
2. My retention is better if I can see new information in charts, diagrams and graphics.
3. I learn a lot from small group discussions.
4. I would prefer hiking in the woods to reading about it in a library.
5. I learn best by attending lectures and listening to knowledgeable instructors.
6. Watching a video is an ideal way for me to learn a new skill.
7. I would rather read a book about gardening and flowers than actually plant a garden.
8. I can solve problems by trial and error.
9. I can attend a lecture and remember most of what was said without the aid of notes.
10. I seem to learn best from books and manuals.
11. I enjoyed such classes as science lab, typing and shop.
12. Audio tapes are a more effective learning tool for me than videotapes.
13. I understand Beethoven because I enjoy listening to his music.
14. I have no trouble reading maps.

15. I don't need instructions to assemble a model airplane.

Survey Says ...

This short survey is not designed to scientifically identify your learning profile with 100 percent accuracy, but it does provide an indication of how you might normally learn best. Basically, this quiz attempts to determine if you learn best by seeing it, by hearing it or by touching and doing it. Are you primarily a visual learner, an auditory learner or a kinesthetic learner?

True responses to questions 2, 6, 7, 10 and 14 indicate a **visual learner**. You are a person who seems to learn well by reading, spending time in a library, using videotapes, etc.

True responses to questions 3, 5, 9, 12 and 13 are representative of the **auditory learner**. You get more out of learning when you hear it, as opposed to reading about it. You spend more time attending lectures or listening to tapes than reading or going to the library.

True responses to questions 1, 4, 8, 11 and 15 would identify you as a doer. You are a **kinesthetic learner**. You learn by touching it, physically working with it (as opposed to reading about it) or attending a lecture. At Christmas, you're the person who doesn't bother to read the assembly instructions for a child's toy. You just rip open the box, pull out 101 pieces and proceed (often by trial and error) to assemble the toy.

So, for example, if you had five true responses for the visual learning statements, two true responses for

the auditory statements and one for the kinesthetic, you probably learn best through your sense of vision. Accordingly, if you are forced to listen to a lecture for an hour, you may not get as much out of that learning experience as you would if you had the opportunity to read and study the lecture notes.

It is possible that you may have four or five true responses for more than one method of learning. For example, you may learn equally well by auditory or visual methods. However, most adults seem to favor one method of learning over the others.

Once you identify your learning profile, it stands to reason that when faced with or forced into a learning situation, you should attempt to gear the teaching style to your learning profile. If you are a visual learner and you're given the choice of reading material or listening to information, you probably should elect reading. This will improve your learning—i.e., your comprehension and retention.

If you are about to embark on a learning activity that is primarily a lecture format and you view yourself as an auditory learner, take a tape recorder to the session, so that you can listen to it again and reinforce what was learned.

To Be Young Again!

As a young child, you possessed a totally open mind. Your brain was a sponge and you probably learned equally well by all three methods of learning.

If you learned to walk at a very early age (before 1 year of age), your parents probably thought you were a genius. Actually, you were simply demonstrating your kinesthetic learning abilities.

If you possessed good hand to eye coordination—if you could throw or catch a ball at a young age—you were using your kinesthetic learning skills.

Usually, an infant or a toddler spends a lot of time touching objects, attempting to reach for objects, putting various things in his or her mouth, etc. The child is learning kinesthetically.

Small children also will learn visually. As our kinesthetic learner becomes 1 or 2, possibly, much time is spent learning visually. It is not uncommon to substitute the TV as a baby sitter for a toddler. A 1-year-old may not be able to say, "Barney" or "Big Bird," but that child recognizes these characters from exposure to TV or videos.

Very often, when you speak to 2- or 3-year-olds, they will get that faraway look in their eyes, as if they were actually seeing something. For example, you may say to a 3-year-old, "Do you remember what Santa brought you last Christmas?" Before the child responds, he or she begins to gaze at a wall or window, as if last Christmas were being replayed before his or her eyes. The child is clearly reflecting learning (memory) based on visual stimulation.

Early understanding of language, such as "No," "Don't touch" or "Where's Daddy?" are examples of a child learning through the sense of hearing. Very young children, such as 3- or 4-year-olds, can learn foreign languages easily, probably more easily than many adults. Coupled with their sponge-like brains is the ability to learn very effectively by listening to words and phrases.

Generally, children are very flexible. They have

not formed any opinions regarding learning. They have not yet been inhibited by teachers or the formal learning system. Many children learn equally well through the senses of touch, hearing and vision.

For example, if parents begin to read books to children at a very young age (less than one year even), the children generally will exhibit all three learning processes. Infant and toddler books are usually made of heavy paper or cardboard. Why? The book will be held, dropped and tossed by the toddler. Chances are that the book will end up in the baby's mouth at some point. Due to the kinesthetic learning process, publishers must make these books nearly indestructible.

As the parent reads the book, sooner or later, the child will attempt to repeat some of the words or sounds. The dog may become a "bow wow." A car is simply a grunting or roaring sound. The child is learning by hearing. Very often, a child who is read to at an early age becomes an early talker.

Needless to say, reading to toddlers also serves to help the child learn visually. Big Bird and Winnie the Pooh become recognizable characters for the child. The toddler will identify and select a book and hand it to the parent so that it can be read.

To have these same uninhibited learning mechanisms working for us throughout life would be ideal. Unfortunately, we most often reach a point early in life at which we begin to lose interest in learning. Sadly, this point usually is reached early in our exposure to education, as practiced in the school systems.

> **Irrelevancy + Boredom = Negative Learning**

As young children, we eagerly and enthusiastically approach kindergarten. We bring a very flexible learning profile to the beginning of our formal education. We have been doing very well as visual, auditory and kinesthetic learners.

Kindergarten is frequently an extension of preschool programs or the learning that takes place in the home. There's a lot of exploring, movement and activity in kindergarten. The teacher replaces the parent as a disciplinarian and a reader of books.

However, as we progress through elementary school, the flexibility and informality of the kindergarten classroom, which complements the child's learning profile, gives way to a more formal, structured environment. Frequently, by about the fifth or sixth grade, a new word is heard to describe the learning environment—"boring"!

Usually at this point, the eagerness and enthusiasm that marked our entrance into the formal education process now give way to an apathetic, docile attitude toward school and learning.

In reality, the process of learning is seldom boring. What becomes boring are the limitations placed on learning by the system and the methods of teaching.

The happy, exciting, active environment of kindergarten has been replaced by students sitting passively in rows, being exposed to a one-sided dialogue

as expressed by the teacher. Suddenly, the fifth and sixth graders proclaim that school isn't fun. It's not interesting anymore. It's plain boring! What is really being said is that the curriculum, the learning environment and the teacher's methods are boring and don't fit the needs and expectations of the average 10- or 11-year-old.

Unfortunately, this means we now begin to learn something new—learning is a chore. It's a necessary evil. We now begin to form some negative attitudes regarding school and learning. And as we approach middle school and adolescence, with its accompanying physical and emotional changes, this newly developed negative attitude toward learning is easily reinforced.

Fortunately, for most of us, the turmoil of adolescence eventually ends, and somewhere around the senior year of high school or later, our adult values, beliefs, expectations, goals, etc., begin to take shape. However, learning and the need for and place of education in our lives will probably never again be what they were when we were 5 and 6 years old.

The learning experience has been distorted by school systems, philosophies and teaching methods that were threatening, boring and meaningless. Possibly, you've developed a visual learning profile, but the system requires you to learn first by listening to the drone of the teacher, and secondarily by reading textbooks. You may be totally non-kinesthetic as a learner, yet you are forced to spend time in physical education classes, as well as possibly typing and shop classes. When a student fails physical education, it is really

the school system failing the child, as the system simply doesn't recognize that not everyone is capable of throwing a ball or shooting a basket. Individual learning styles are ignored for the sake of a standardized curriculum and rigid teaching methods.

As a preschooler, you never thought of failure. You didn't even know what failure was. As an elementary school student and later a high school student, you seemed to learn enough to avoid receiving a grade of less than C average. You learned to learn out of fear—fear of not pleasing someone due to a poor grade. The enthusiasm and pure joy of learning were replaced by fear of failure as a prime motivation.

College usually reinforces your negative feelings regarding learning and education. Regardless of your learning profile, auditory learning becomes the primary mechanism. For example, you may sit in lectures with 100 or more other students while a professor (or a professor's student assistant) lectures from a rigid set of notes. For the most part, questions are not permitted. Your ability to withstand this situation will be evidenced by a midterm and final exam—actually a test of your patience and tolerance, as opposed to what you have learned.

College becomes bearable as a learning experience because, here and there, you are able to choose classes that are relevant and allow you to temporarily regain a little of the old enthusiasm for learning. College also becomes bearable because it's like paying your dues (especially if you're paying your own tuition). If you are going to get a good job and have a career, college is the price you must pay for the future. After all, this

imprisonment is only for four or five years, and then you will be released by way of graduation.

Unfortunately, college may have compounded the negative learning attitude that was born in late elementary school and flourished during your high school days. You leave college, ready for the adult working world. You can add and subtract and write a business letter, and you possess some basic knowledge and work-related skills. You generally feel that you're done with school, done with learning. You want to put this somewhat negative experience behind you and get on with life.

What This All Means

Today, you are 30 or 40 or 50 years of age. You have some work experience under your belt. And you probably have some negative attitudes toward school and "book learning."

Unfortunately, your manager has informed you of some upcoming cutbacks, known as downsizing. You begin to ask yourself, "Will it be me?" Your company's initial reorganization passes you by. You still have your job. You're a survivor!

You now begin to think about the next reengineering, which will undoubtedly take place within the next few years, and begin to question your ability to survive continued cutbacks.

As part of this self-assessment, you probably will recognize the need to improve some job skills and advance your formal education. You must become more valuable to the organization. The skills you've acquired over the years no longer match the exacting needs of a changing marketplace. In short, you now must become an adult learner.

It may have been 10 or 20 years since you graduated from school. You now approach this challenge of learning new things as an adult with some trepidation and anxiety. You haven't sat in a classroom in years! You haven't taken an exam that meant anything in years! How can you compete with younger, bright-eyed recent college graduates?

The relief for your anxiety and the answer to this question will center on your ability to approach the challenge of adult learning by rekindling the enthusiasm, positive attitude and self-motivation of your youth.

In addition, you must sharpen those learning skills again. Fortunately, your intelligence, learning skills and abilities are still there. And your occupational survival depends on them.

Summary

We learned to learn many years ago as children. To be an effective adult learner requires us to resurrect those early positive childhood learning experiences in terms of attitude and motivation.

In addition, we need to determine how we learn. We need to identify our learning profile as adults. Understanding the learning process, coupled with a positive attitude and enthusiasm for learning, should make us effective adult learners.

3 The Survival of the Fittest

Many years ago, Charles Darwin provided the world with the theory of evolution. The primary tenet of this theory was the concept of mass selection of the fittest. Those organisms and species that were able to adapt to changes in their environment survived. Those that failed to adapt became extinct.

The previous chapter presented a picture of a totally enthusiastic and uninhibited child learner being changed into a passive, intimidated adult learner due to the system—teachers, teaching methods, curricula and failure to allow for individual differences.

In all fairness, the generalizations made were not intended to be a universal indictment of education and learning in the United States. We have some outstanding educators. We enjoy some of the best schools in the world. However, in general, the educational system and learning theory and practices are, and probably always will be, in need of review and change. Such an endeavor is time consuming and, consequently, today's needed changes may not occur for many years, by which time they will require reconsideration and further modification.

Since education and learning always may be imperfect at best and continuously in a state of change,

what can the learner do to facilitate and improve the quality of learning? Basically, the answer to this question is that the adult learner must be able to adapt to the learning environment in order to survive and benefit from the imperfect system. This means understanding how we learn, sharpening our adult learning skills and approaching learning with a positive attitude.

> ## Survival = Understanding + Skills + Attitude

The first two chapters of this book discussed motivation and attitude toward learning, as well as our learning profiles. Subsequent chapters will focus on the development or redevelopment of learning skills. This chapter will deal primarily with adapting to the existing learning and educational systems.

Allow History to Repeat Itself

As we have all heard, history repeats itself. Think back to a specific learning situation when you were a child or a young adult. Why did you enjoy this learning situation? Why was it successful? What was your motivation or attitude toward this learning activity?

Attempting to analyze situations such as this, where successful and positive learning has taken place, may help you to adapt a current learning experience and thus realize a more positive return on your learning investment.

As a guide to this historical perspective, ask yourself the following sample questions (or as many as would be applicable to your situation). Feel free to add questions to this learning inventory.

Learning Experience Survey

1. What type of learner are you (auditory, visual, kinesthetic)?

2. Describe a learning experience in your past that you really feel positive about, including whether it was a formal educational experience, job-related experience, learning a hobby, etc.

3. What was your motivation for becoming involved in this learning situation?

4. How much time did you spend in this learning situation?

5. How did you feel about this learning situation:
a. Before you became involved in it?
b. During the learning experience?
c. At the conclusion of the learning situation?

6. Did you receive any help or assistance during this learning activity?
a. If so, from whom?
b. How valuable or positive was this assistance?

7. What did you enjoy most about this learning experience?

8. What did you enjoy least about this experience?

9. What value does this learning experience have in your life today?

10. In retrospect, is there anything about this learning experience that you would change today?

What you now need to do is take the positives from this past learning situation and attempt to adapt them to a present-day learning activity.

Let's assume the following hypothetical responses to this 10-question survey from an individual we will identify as Charlie:

Charlie's Survey Responses

1. What type of learner are you (auditory, visual, kinesthetic)?

 Primarily a visual learner; secondarily an auditory learner.

2. Describe a learning experience in your past that you really feel positive about, including whether it was a formal educational experience, job-related experience, learning a hobby, etc.

 A very positive learning experience: Taking a college trigonometry course (in another state) in which a minimum grade of a C had to be earned to transfer credit to another college.

 This was intended to satisfy the math requirement for a liberal arts degree.

3. What was your motivation for becoming involved in this learning situation?

 Motivation—to complete math requirements for a B.A. degree and the transfer of the credit to a college in another (resident) state.

4. How much time did you spend in this learning situation?

 Time spent—a college semester attending class twice per week, with an average of 15 hours per week in study time.

5. How did you feel about this learning situation:
 a. Before you became involved in it?
 b. During the learning experience?
 c. At the conclusion of the learning situation?

Feelings prior to enrollment in course—very apprehensive.

Feelings during the learning situation—extreme apprehension.

Feelings at conclusion—relief, pride and personal satisfaction.

6. Did you receive any help or assistance during this learning activity?
 a. If so, from whom?
 b. How valuable or positive was this assistance?

Received no assistance during this learning experience.

7. What did you enjoy most about this learning experience?

Enjoyed most the feelings of relief and personal satisfaction at the end of the semester. Earned the required C.

8. What did you enjoy least about this experience?

Enjoyed least the weeks of apprehension and frustration. Had never received any grade higher than a D in college math. Never received any grade higher than C in high school math. Always had a very negative attitude toward math.

9. What value does this learning experience have in your life today?

Proved that commitment, perseverance and a positive attitude can result in a successful learning experience.

10. In retrospect, is there anything about this learning experience that you would change today?

No changes in the actual learning experience. In retrospect, would have tried to do better in math classes prior to college so as to have a better mathematical foundation.

We now can analyze the answers to this survey, which can be used to develop a strategy or direction that will enable Charlie to adapt to a current learning situation. In other words, history can repeat itself. If certain behaviors proved to be beneficial in a prior learning situation, these same behaviors, possibly with some modification, may also work today for Charlie. From the survey responses, the following observations can be made:

Charlie is certainly not a mathematician. Fortunately, as a visual learner, the trigonometry class was probably presented in a visual manner for the most part (as opposed to auditory).

Charlie was attempting to become involved in a learning activity in which he had never experienced much success in the past, as evidenced by his grades. He was taking a risk that if a minimum grade of C was not attained, the credit could not be transferred. Clearly, the

motivation to complete the math requirements for his degree offset the potential risk.

Charlie experienced a great amount of frustration and apprehension for an entire semester, yet by means of a very positive attitude, prevailed and earned a C. The easy way out would have been to drop the class and avoid the emotional turmoil.

The positive aspects of this learning experience included:

- Maintaining a positive attitude.

- A commitment to achieving a goal.

- Perseverance when the odds were against achieving the C for the course.

We could assume that his was a difficult learning experience in that the risk of failure was extremely high. If Charlie transfers the positive aspects of this experience to current difficult learning activities, he could draw on this prior experience by knowing that a positive attitude, proper motivation and "not quitting" enabled attainment of the goal. Notice that Charlie doesn't mention the grade of C as contributing to the positive nature of his overall experience, but does mention those intangible traits that were necessary to reach his goal.

Timing Is Everything

In addition to the types of questions presented in this learning survey, other questions and considerations may need to be addressed to analyze a prior learning

experience and effectively plan for a current learning activity.

For example, are you a morning person or an afternoon person? Are you at your mental peak before lunch or after lunch? Naturally, if you are a morning person, you would want to schedule a learning situation or a test for the morning hours. Conversely, if you don't get into high gear until after lunch, then your learning or testing activity probably should be scheduled for that time.

Generally, it isn't possible to remain in a high mental state throughout an entire day. Due to metabolism, as well as prior work or scheduling experience, there are individuals who function better in the morning than later in the day. If you are used to getting up at 5:30 a.m. every day and you're in the office by 7 a.m., you're probably a morning person.

Solo or Group Study

Based on past learning experiences, you might ask yourself, "Do I learn best by myself, or do I learn better in a small group situation?" There are adults who can spend hours and days in a library in solitude, and learning takes place. On the other hand, some individuals require interaction with others to facilitate the learning process.

For example, several years ago, I was in the San Francisco area doing some training for a group of 15 insurance agents. This course was a three-day program covering various types of securities, such as mutual funds, stocks and bonds, as well as federal regulations governing the sale and distribution of these investment

products. The purpose of the training was to prepare the insurance agents for a federal securities examination.

There was a minor problem: All 15 insurance agents were Chinese, and two-thirds of them spoke little or no English. Luckily, while in the U.S. Air Force (many years earlier), I had been trained as a Chinese linguist, so all was not lost. I was able to translate a few English terms into Chinese—but, for the most part, I knew that I was reaching very few of them. However, much to my surprise, this group of highly motivated Chinese-Americans did very well over the three-day class. The class ran from 8:30 a.m. to 4:30 p.m., after which this group went to dinner and returned to the office until approximately 11 at night. During these late-night sessions, they formed small groups with the three or four individuals who were bilingual and discussed and learned what topics and concepts had been presented during the day. Without this small group effort on their part, the entire three-day training program probably would have been a disaster.

Not only can working with peers facilitate the learning process, but often this activity serves as motivation for achieving the learning goal. In retrospect, this group of Chinese agents feared failing the federal securities exam, so they put in 15-hour days.

This chapter has been stressing positive learning experiences. Possibly just as much can be learned by reviewing your negative learning experiences. You might ask yourself why the experience did not succeed. Were you properly motivated? Was the learning

experience relevant to your needs or situation? Did you have a negative attitude toward the learning activity?

In other words, we learn from past experiences—good or bad. Then, as an adult learner, we build on these experiences for current and future learning experiences.

Different Learning Situations

The main point here is that you must be able to adapt to different learning situations as an adult. We might label learning situations as:

- The classroom situation

- Technical situations

- Hands-on situations

- Private learning

The **classroom situation** is the traditional SOL experience—"sit, observe and listen." If you happen to be primarily a kinesthetic learner, you will have to adapt your learning behavior to this visual and auditory environment.

Remember, the kinesthetic learner craves activity. Therefore, don't become a passive observer when you are forced to endure the typical classroom presentation, where the instructor lectures, uses the board occasionally and asks for little participation from his prisoners!

Become an active participant in this classroom presentation. Ask questions. Make comments. Raise relevant issues. Stimulate activity and participation.

Technical learning situations would involve the use of such technical devices as videotapes, computers

and audio tapes. Frequently, the adult learner develops a phobia with regard to high-tech gadgets. The individual approaches this learning environment with a considerable amount of apprehension, and frequently is intimidated by these "machines." If you are stuck with this approach, it is important to adapt accordingly so that learning can take place.

Often, various types of tests and licensing exams are computer-based. An adult may fail such a test simply because of lack of familiarity with the computer. Survival in this learning environment requires adaptation.

Hands-on learning situations naturally are the favorite of the kinesthetic learner. There's action and activity. The learner becomes physically involved. On-the-job skills training would be a common type of hands-on learning situation. For example, the individual learns how to operate a computer by actual practicing on the computer.

Adapting to this learning situation generally requires a willingness to use trial and error as a tool. Practice and repetition are essential ingredients. The individual must learn from repeated mistakes.

Private learning or independent learning simply refers to those situations where the individual is "self-taught." It's a do-it-yourself approach to learning. To be successful, the learner must be able to establish an objective or goal, then take the necessary steps to reach this goal. Thus, a certain amount of self-discipline is required.

Typically, private learning requires that the individual also be able to identify and locate resources for

purposes of acquiring certain types of information. A necessary technique or adaptive skill requires the learner to possess a degree of self-motivation, since there is normally no outside force directing completion of the learning task.

Generally, the person who can adapt to this type of learning environment is the "go-getter" who becomes a learned person without a lot of formal education. The private learner is not the lifelong student who reaches a comfort level in the traditional classroom situation.

Setting Goals

As an adult, you need to set certain learning goals, just as you would establish any other work-related goals or personal goals.

What is it that you want to learn more about? How much time can you devote to this learning objective—and when? How will you reach this goal (formal learning or private learning)? When are your best or worst times to study?

Learning goals need to be realistic. Don't bite off more than you can chew. Don't establish a learning goal that you may not be capable of attaining. And don't frustrate yourself by creating a goal that is not meaningful.

Summary

Learning takes place in various ways. We have discussed the concepts of visual learning, auditory learning, and kinesthetic learning. As a child, we learned by all three methods. As an adult learner, we tend to favor one method over the others.

If it has been many years since you were placed in a serious learning situation, you may want to go back in time and review and analyze what used to work for you as a young learner. You should determine the type of learner you are and extract from previous learning experiences those situations and activities that were very positive. What was it that made the learning experience meaningful? You also can learn from your earlier negative experiences.

To achieve success, the adult learner must be ready to establish educational goals, and make changes to adapt to various learning activities and situations. Adaptation means survival. Fail to adapt and the learning light is extinguished.

Reading Aggressively

The first three chapters of this book dealt with some technical aspects of learning, as well as the key ingredients of motivation and attitude. An effective learning formula was suggested:

> **Effective Learning =**
> **Enthusiasm + Attitude + Skills**

The balance of this book will deal primarily with learning skills as the final element in this formula.

The Three R's

Probably the most important learning skill you have is your ability to read, read, read. Effective reading is the most critical element for becoming a successful adult learner (or for learning at any age).

As adults, we learned how to read many years ago. This chapter obviously will not teach you how to read, but rather how to improve your reading comprehension and get the most from what you do read.

Let's look at an example:

Leslie is a married woman who had been away from the work force for approximately 20 years

while taking care of her home and raising three children. About two years ago, she began working for an insurance company as an assistant claims processor. Initially, she was provided with a two-day training program on how to operate the computer at her desk, as well as some on-the-job training relative to claims processing. Last month, she was promoted to lead claims processor. This promotion requires her to participate in a two-week training program at the company's main office in another state.

To this end, Leslie's boss has given her two very thick manuals—one on computer programs and the other on more advanced claims processing. Each manual consists of approximately 200 pages, around which the two-week training program is built. Her boss has instructed her to "browse" through the materials before she leaves for the main office next week. Leslie feels completely overwhelmed by this pre-training activity.

She has started to read the material on several occasions, only to feel very frustrated, as she is not sure what it is she's reading. She has attempted to take some notes from her reading, but this too leaves her frustrated. She concludes that being out of the learning cycle for nearly 20 years has taken its toll. She is concerned about failure and not doing well in this upcoming training situation.

Obviously, Leslie can read. However, it's one thing to read a novel for pleasure and relaxation. It's another thing to have to read and study for purposes of learning some new technology and job-related skills.

The first thing Leslie should do is take a deep breath and relax. She should recall some positive learning experiences from her past, which she may call upon for some type of reinforcement. She needs to replace her frustration and apprehension with an enthusiastic and positive attitude toward this learning experience.

Then she may need to oil the gears of her reading skill machinery by doing some or all of the following activities.

"Browsing," as suggested by her boss, is the place for Leslie to begin. However, it must be effective and meaningful browsing. We might refer to this as **previewing**.

Previewing

> **Previewing is a systematic exploration of a reading assignment.**

When handed a book to look at, how many of us open to the end of the book and begin to flip pages moving toward the front of the book. We certainly don't read from the back to the front. Why browse or preview from the back to the front?

Effective previewing requires that you start at the beginning—not the end! Read the book's introduction or preface to determine the purpose or objective of the book. Then scan or survey the table of contents. Treat the table of contents as a map that will guide you on your journey through the pages.

Now you understand the purpose of your trip through these pages, and you should have a feeling for

the direction in which you will be headed.

Scan the contents of the book itself by reading chapter headings and subheadings. Take a look at any graphics or visuals. If a particular paragraph catches your eye, stop and read it. You may even want to write down an idea or two that you get from reading a paragraph.

Once your mind has an image of the entire contents of the book, you can begin to look at smaller parts of the map by previewing each chapter before it is read. For example, preview chapter one before you begin to read it; then preview chapter two before you read it, and so on. By previewing each chapter, you are now getting focused on specific smaller bits of information.

By systematically "browsing" in this manner, you are relieving some of the anxiety and apprehension caused by the unfamiliarity of your reading task. You also now have an image of what to expect. By previewing this material, you will likely increase your comprehension and retention when you actually begin to read and study.

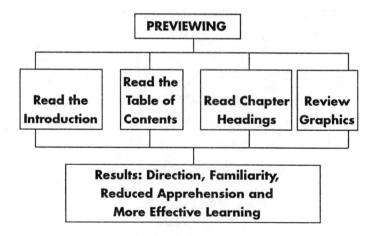

Chapter 4—Reading Aggressively

Leslie's training manuals are not romance novels. If they were, she could read them in a leisurely manner, without any anxiety. These are technical manuals that require an aggressive reading style. **Reading aggressively** implies becoming involved in and focused on the reading activity. In Leslie's case, after previewing, she needs to attack this technical reading project.

Attack! Attack! Attack!

Reading Aggressively = Involvement + Focus

You cannot lapse into the passive student role that is common in high school and college. You cannot simply stare at the words as if you were staring at the clock or your high school math teacher.

Reading is a thinking process. You must become involved with the words on the printed page, so that you can improve your comprehension and retention.

The main reasons for comprehension problems are lack of proper concentration and a passive reading style. You must become involved with the task at hand—i.e., reading technical material—by actively throwing yourself into the reading activity. You need to develop certain habits and techniques to become an aggressive reader. These techniques include the following approaches.

> **Read with a pen in your hand**: Be prepared to underline, make notes and draw diagrams. Take notes or underline with a pen, a highlighter or both. Do what works best for you. Some learners prefer highlighters; others prefer pens. Some individuals may underline a

word or phrase in one color and use a different color to underline other important facts.

Be sure to **highlight or underline** words or sentences that seem to be **definitions**. This is especially helpful if your reading assignment is to be followed by a test of some sort.

Underline the topic sentence of most paragraphs. Generally, the topic sentence will be the first or second sentence in a paragraph. It basically tells you what the paragraph is about. It usually represents the main idea or concept from which the balance of the paragraph flows.

Underline any examples that may be used to explain a topic or concept. Very often, we are able to retain examples or mental pictures more easily than a stream of words. Thus, focusing on the examples can improve comprehension.

Your Sample
Reading
Assignment

Read the following paragraphs. Then go back through each paragraph and underline the topic sentence and any definition(s) and/or examples that might appear. As a suggestion, you may want to use a highlighter to identify the topic sentences, since these sentences specify the main topic to be discussed in the paragraph. Underlining could also be done with two different colored pens—e.g., red for definitions and black for examples. Then, when you need to review this material later, you can quickly identify impor-

tant concepts and ideas. Naturally, you can simply underline in one color if you wish.

There is little question that our population is aging and living longer. Therefore, you may wish to purchase an annuity to protect yourself against the financial risk of living too long. An annuity is a contract that guarantees an income for life. Whether you live to be 65, 85 or 105, an annuity will provide you with a monthly income. This assurance of a lifetime income is known as the mortality guarantee. No other investment or retirement product can make this guarantee. This makes an annuity an ideal retirement vehicle.

The keys to a financially secure retirement are time and money. A person who begins to set aside money at age 55 for retirement at age 65 may not achieve the same financially secure retirement as an individual who begins accumulating money for retirement purposes at age 35. The larger the sum of money accumulated over a long period of time, the more secure the retirement years will be.

Paragraph 1: The topic sentence is usually the first or second sentence in the paragraph. In this paragraph, it is the second sentence. The main topic is that an annuity can protect you against the risk of living too long.

The third sentence is a definition of an annuity: a contract that guarantees an income for life.

The fifth sentence defines the guarantee of mortality: the assurance of a monthly income for life.

Paragraph 2: The topic sentence is the first sentence, which states that time and money are the key elements for a financially secure retirement.

The second sentence is an example of what is meant by the use of time and money when planning for retirement.

We hope you did well on this exercise. When reading technical or unfamiliar material, be an aggressive reader. It is important to extract main ideas and important concepts from the material by means of note taking or underlining.

In the example at the beginning of this chapter, Leslie is responsible for reading and studying technical material for a two-week training program. Undoubtedly, she will be tested on what she learns. By marking and underlining topic sentences, definitions and examples, she can easily review these reading assignments for testing purposes.

Be Inquisitive

As an aggressive reader dealing with unfamiliar or technical material, ask yourself questions. Ask the instructor questions. Read with questions in your mind. If these questions are unanswered following a reading assignment, write them down and ask the instructor or another student.

For example, as you preview a chapter or section of the reading material, you might begin by asking yourself **what**—what should I learn?

Another question to ask yourself is **how**—how can I best learn this material? After you have previewed the reading assignment, you need to determine the best approach for reading and retention of the material. Should I take notes on every paragraph? Should I underline or highlight information? If the reading is "light," then you may not have to do much else, other than concentrate and read. If the material is unfamiliar and technical, then you probably should devise a plan or system as to how you should attack the information.

As noted earlier, as a 3- or 4-year-old child, one of your favorite words was **why**. Think of all of the mysteries and unknown information that word unlocked for you. As an adult learner, don't hesitate to ask why.

In addition, if your reading assignment leads to an exam, you might want to jot down possible test questions as you read, to aid in your retention. For example, you may read a paragraph or two and then compose some "test questions" based on the content of the paragraph. This can aid in the comprehension and retention of the information.

To illustrate this idea, read the following paragraphs. You'll want to get out your notebook again so you can record the topic sentences and any definitions or examples, then write some sample "test questions."

Write Practice Questions

Paragraph 1

Medicare is a federal program of health care for the aged and the disabled. Aged means attainment

of age 65. Disabled refers to those who have collected Social Security disability benefits for at least 24 months and those who have serious kidney problems resulting in dialysis treatment for at least three months. Medicare is administered by the Health Care Financing Administration through various Social Security offices throughout the country.

Paragraph 2

Medicare consists of two parts—Part A and Part B. Part A is hospital insurance and primarily covers inpatient expenses incurred while hospitalized. Types of covered expenses include hospital room and board, general nursing services and inpatient physical therapy. Attainment of age 65 and prior payment of the Medicare tax (as part of the total Social Security tax) qualify a person for Part A benefits. Thus, it is an automatic benefit that has been prepaid through your taxes while you were employed.

Paragraph 3

Part B of Medicare covers outpatient expenses and the expenses associated with the services of physicians and surgeons. Part B is also known as medical insurance. Unlike Part A, Part B is not automatic. You must enroll in Part B and begin paying a monthly premium for these benefits. This enrollment generally takes place at age 65, at the

same time you achieve eligibility for Part A benefits. Types of benefits provided by Part B include outpatient therapy, doctor's office calls, surgeon's fees and diagnostic services.

Paragraph 1: The topic sentence in Paragraph 1 is the first sentence. This sentence also serves as a definition of Medicare. Following the first sentence are two sentences that define the meaning of aged and disabled.

Typical questions could be the following:

- How does a person attain Medicare eligibility?

- What organization administers the Medicare program?

- How can Medicare be defined?

Paragraph 2: The topic sentence is the second sentence (the entire paragraph, except for the first sentence, addresses Part A of Medicare). This second sentence also defines Part A. The third sentence provides examples of covered services.

Sample questions:

- What are the two principal parts of Medicare?

- When does a person achieve eligibility for Part A of Medicare?

- Who pays for Part A of Medicare?

Paragraph 3: The topic sentence is the first sentence. The second sentence offers a definition (or synonym) for Part B. The last sentence provides examples of Part B benefits.

Sample questions:

- What type of expenses are covered by Part B of Medicare?

- How do you acquire Part B benefits?

- What are some examples of Part B benefits?

Notice the inquisitor's language—what, how, who, when. Asking yourself these questions or actually writing them down allows you to carefully dissect each paragraph, so that you can better understand and retain this information.

Granted, this may be a slow process, but if reading comprehension and retention are obstacles to effective learning for you, then becoming both an aggressive reader and an inquisitive reader should alleviate this problem. This is especially true if you are reading unfamiliar material or technical information. It is also a good study technique if you are preparing for a test.

Review

A final step for your aggressive reading style is to review what you've read. You started this entire process by previewing what was to be read, and you now conclude with a review of what you did read.

Very often, this review process is made easy for you, as frequently there will be a "review section" at the end of a chapter. Usually, this section will review the key ideas and main concepts found throughout the chapter. This section serves as a guide through the chapter. Thus, as you read the review material, if you don't understand something or don't remember a point, you can go back into the chapter and reread the section that covers your problem area.

Naturally, you also can review by going back over your margin notes, underlined sentences and any questions you may have formed. By rereading all topic sentences, you will review the main concepts presented. To enhance your understanding of those main concepts, you can review the underlined definitions and/or examples. Any questions that you may have formed based on material in various paragraphs can serve as a summary of relevant pieces of information. When using the questions as part of your review, take the time to answer your own questions.

Pay Attention!

I knew a high school English teacher whose favorite question was, "Are you paying attention?" He would lecture about an author such as Shakespeare for 10 or 15 minutes. He would then usually detect a student with a distant, faraway look in his eyes. The teacher would suddenly come face to face with this individual and shout, "Are you paying attention?" The response was always the same, a frantic "Yes." The teacher would then say, "Can you repeat what I just said?" At this point the student would begin to search for words in an effort to repeat what he hadn't heard about Shakespeare. The teacher would then say in a louder voice, "Can you repeat what I just said?" Usually, silence followed, as the bewildered student wasn't sure what to say.

Not only was there a lack of concentration by the student during the lecture on Shakespeare, there was a continued lack of concentration evidenced by the student's inability to answer the second question correctly. The answer the teacher expected for the ques-

tion, "Can you repeat what I just said?" was simply a "Yes" or a "No." That's the only possible answer if the person is actually concentrating and listening to the question!

In contrast to the high school student whose concentration is lost because he is preoccupied with whom to ask to the next dance, as an adult, your brain is constantly being stimulated with thoughts, images, questions and problems. Your brain is overloaded with impulses and stimuli. To get the most out of your reading, you must be able to block out these problems and obstacles. It's like erasing a board, so that you have a clean slate on which to record information.

Read in Short Spurts

To improve your reading comprehension and retention, you must improve your ability to pay attention and concentrate. You have to erase the board (clear your mind) to make room for new information. We must temporarily remove the adult distractions that bombard our minds daily, such as:

- The mortgage payment is late.

- My child still has that cough.

- I should look for a better-paying job.

- Where will we go on our next vacation?

The problem is that we can only erase the board for short periods of time. Sooner or later, our distractions and problems will reappear. Most people can only concentrate for relatively short periods. If you are average, 10 to 15 minutes is your maximum concentration span. If you are slightly above average, you may

be able to concentrate for 15 to 20 minutes at a time before the distractions return.

Thus, you should read in short spurts. If you are able to concentrate for about 15 minutes but read for an entire hour, you will probably have pretty good recall of what was read in the first 15 minutes, but the final 45 minutes could become a nightmarish blur.

When you start to lose your concentration, stop reading briefly. Erase the board and start another focused reading segment with a clean slate.

Initially, you may wish to start with 10- or 15-minute reading segments. In between each segment, allow about 5 minutes of non-reading time. Make some marginal notes or simply have a cup of coffee. Take a short break, followed by another focused reading period. You'll probably find that you will be able to extend your focused reading time from 15 to 20 minutes and then, possibly, 25 minutes. You may eventually be able to read for 30 minutes at a time at the peak of your concentration.

Before each subsequent reading period, briefly review what you've read during the preceding 15-minute segment. That is, review your notes and any underlined sentences, and then proceed to read for another concentrated 15-minute period.

Using this method forces you to begin and continue a reading assignment in small bits and pieces. For example, you may establish an hour of reading as your goal. Don't force feed yourself. Take it in small doses—15 minutes at a time. You'll find that you can digest this material more effectively than by a forced one hour of reading.

Staying Focused

This method of using concentration to improve retention is especially useful when you must read technical or unfamiliar material. When reading simply for enjoyment, you may find that you can read for long periods of time before your mind starts to wander. However, the more difficult the reading, the shorter your concentration in terms of time.

In addition to using this focusing method, there are other considerations when it comes to attaining good concentration and retention of reading material. For example, be well rested before you begin your reading. Reading for enjoyment at the end of a long, hard day at the office may be relaxing. Beginning a difficult technical reading assignment at 9 o'clock at night may be disastrous. If you are a morning person, do your heavy reading in the morning, not later in the day.

You also should not sit down to read on an empty stomach, nor a very full stomach. If you feel a bit hungry, your hunger becomes a distraction. On the other hand, beginning your study or reading assignment after having had lunch at an all-you-can-eat, country fried food buffet will tend to result in zzzz's—you're going to fall asleep!

To aid in your concentration efforts, find a place to read where the lighting is good, the room temperature is right and the general conditions and environment lend themselves to learning. You may want to play some soft music, but certainly nothing distracting. Needless to say, if the TV is on, regardless of how effective a reader you may be, your concentration will be split between reading and listening to or watching the TV.

Summary

Sharpening your reading skills can make you an effective adult learner. Your reading skills begin with the process of previewing: systematically exploring your reading assignment before actually taking the trip through the pages. Previewing will provide you with a sense of direction, a degree of familiarity and a reduction of any apprehension or fear you may have.

To be an effective reader, you must be an aggressive reader. Read with a pen in your hand so that you can underline and highlight key ideas and concepts. Read with questions in your mind—or actually write down questions—based on your reading. Finally, always do systematic reviews to reinforce key concepts.

The last ingredient in improving your reading skills is to develop a method of concentration where you read and retain small bits of information in short time segments. Being able to concentrate effectively increases comprehension and retention. This is particularity important when reading or studying unfamiliar or very technical information.

5

Are You Listening?

If you are an auditory learner, the ability to hear is vital, but the ability to listen is even more important. Just as most of us can read, most of us can hear. Some of us can read with effective comprehension. Some of us can listen with effective comprehension.

Listening = Hearing + Comprehension

We could define hearing as the perception of sounds through auditory stimulation. To raise the old philosophical question:

If a tree falls in the forest and there's no one there to hear it, does the falling tree really produce a sound?

The answer to this question was always a subject for debate in Philosophy 102! There were those who said that no sound was produced, since no auditory stimulation had been perceived by anyone.

Listening provides meaning and understanding to what we hear. We may hear the noise of the falling tree (auditory stimulation). Listening carefully, we conclude that this noise represents a tree that has fallen.

Effective
Listening

Effective listening evokes questions and response from the listener. Listening is hearing with comprehension, just as reading effectively means reading with comprehension.

Thus, you could be attending a lecture and hear sounds coming from the speaker, but your mind is elsewhere. You are preoccupied with your own thoughts. True, you are hearing something, but you're not listening.

We spend much of our time in a hearing/listening mode. We are able to comprehend that a tree has fallen in the woods, from the noise we hear as well as the forest we see. On the job, we participate in meetings and spend considerable time on the telephone. Frequently, we are called upon to make decisions based on verbal information and data. Needless to say, the majority of our formal and informal education involves our auditory sense.

When you hear a person state, "He's a good listener," what is actually being said is that he listens, understands and responds to what he hears. There is a need to be a good listener both on and off the job. Being a good listener at work can increase your value under the new employment contract. As an asset of the corporation, good listeners are better problem solvers and decision makers, and are usually more promotable. In this age of downsizing, reengineering and reorganization, good listeners are often survivors.

A **good listener** is generally a good learner—on or off the job. Whether the task is completing a college course or learning a new job-related skill, the good listener usually does a better job. A good listener is

usually more self-confident and has a positive attitude regarding a learning endeavor. In addition to sharpening your reading skills, as an adult learner, you also need to become a good listener to facilitate the learning process.

Just as you need to become an aggressive reader to improve comprehension, you need to become an active—as opposed to a passive—listener. An active, effective listener is one who:

Becoming an Active Listener

> **Receives information, understands and gives meaning to the information, and responds in some way.**

A passive listener hears but really doesn't listen, comprehend, assimilate information or respond. Conversely, the active or aggressive listener receives the information, understands what's heard and responds to the communication.

If you view yourself as a visual or kinesthetic learner, your auditory skills may not be up to par. For example, as a visual learner, you have relied on reading and your sense of vision as your primary learning tools. Atrophy may have strangled your sense of hearing as a method of learning.

Unfortunately, as adults, we are active listeners only about 25 percent of the time. The other 75 percent of the time we're really not listening effectively. We may hear sounds, but information is easily forgotten or misunderstood. To be an effective adult learner, we need to spend more of our time as active listeners.

The passive listener becomes a passive learner—the tendency is to lapse back to our formal education years, when passive learning was the name of the game. Thus, information enters one ear, becomes distorted or misunderstood, and goes out the other ear. In this instance, the individual is in the forest, hears the tree fall, but is unable to identify the sound or attach meaning to it.

Common Fallacies

No one likes to be scolded, "You're not listening!" To better understand this skill of listening, let's explore some common fallacies.

> "I'm a good listener because I always get the facts and figures straight."

It sounds like you may be a selective listener. You listen for the facts and figures, but don't hear or comprehend the rest of the information, such as questions that are raised, emotions of the speaker, context, opinions and ideas discussed.

> "I'm a good listener because I never interrupt when someone is speaking."

A good listener does interrupt if the information provided by the speaker is unclear. Just as you need to be an inquisitive reader, you also need to be an inquisitive listener to be an effective listener.

> "I'm a good listener because I pay attention to what I hear."

Being able to concentrate or pay attention to a speaker does not necessarily make you a good listener—

unless you can also assimilate, understand and respond to the information being given.

> "I'm able to learn a lot by listening to audio tapes while I drive."

When listening to tapes while driving, your primary focus or attention should be on driving safely. Secondarily, you are listening to the tape. Your attention is split between dodging traffic and trying to listen. Good listeners generally concentrate on a single focus—listening.

> "I can hear. Therefore, I can be an effective listener."

Hearing is the first step in the process of communicating information. Once you hear the information, you must be able to understand it, question it, interpret it and respond to it. A good listener does more than just hear.

Your Listening Profile

How well do you listen? Are you a "good listener"? The answers to these questions depend on a number of factors, which generally revolve around your attitudes and habits regarding listening. Answer the following questions to help identify your listening style.

Listening Survey

Grab your notebook again and write down T for True if you feel the statement describes your listening attitude or behavior. Write F for False if the statement is not descriptive of your listening behavior.

1. Generally, I control my emotions when listening to a speaker.

2. I have little difficulty paying attention to a speaker's message.

3. I always ask some questions during a lecture or training session.

4. I usually take notes during a speaker's presentation.

5. I do not get upset if a speaker's opinions are different from my own.

6. I make good eye contact with a speaker most of the time.

7. I am not easily distracted when listening to most speakers.

8. I evaluate the information given by a speaker, not the speaker himself or herself.

9. Understanding the key points of a verbal presentation is not difficult for me.

10. I respond throughout a speaker's presentation by occasionally nodding my head or smiling to reflect my agreement.

11. It is not difficult to listen to a speaker who is considerably younger than I am.

12. I listen between the lines of a presentation to identify the speaker's emotional message.

13. Prior negative learning experiences do not affect my ability to listen to a speaker.

14. The speaker's delivery and style are not as important as the message.

15. Good listening habits are related to good posture.

If you had 14 to 15 true responses, you should write a book on effective listening habits!

A score of 12 to 13 true responses generally means you're a good listener.

A score of 10 to 11 true responses means you're probably an average listener, but there is certainly room for improvement.

Fewer than 10 true responses indicates you definitely need to sharpen your listening skills.

Typical Non-Listeners

However, before we discuss your listening styles any further, let's identify some typical "non-listeners." The following represents a small group of listening profiles or personalities who, in fact, do not listen effectively.

The impatient listener continually interrupts to ask a question or express an opinion. This is the individual who suddenly thrusts his hand into the air and begins to wave it frantically. The speaker often has not finished a sentence or a thought when interrupted by this impatient listener. Being an inquisitive listener is a positive trait, where questions are asked at the appropriate time. The impatient listener usually asks questions at the wrong time, before all the facts or information are known.

The know-it-all is the listener who always insists on finishing your sentence or thought for you. He or she does not raise a hand but merely blurts out your

concluding words from a sentence or phrase. Obviously, if this person is focused on completing your sentence, much of the information being transmitted will never be heard.

The jumper is the listener who jumps to conclusions before all of the information is known. If a speaker is giving a 15-minute talk, about five to 10 minutes into the discussion, this individual already has the answer or the conclusion without listening to the complete discussion.

Basically, **the daydreamer** doesn't listen. He or she pays little attention to the discussion or conversation. He drifts in and out, and then suddenly gets involved in the conversation by asking a question that has already been answered. Or possibly this person simply wants to change the subject. The speaker can be talking about apples and oranges, and suddenly our daydreamer makes a comment about the merit of fruitcake! The daydreamer is a fragmented listener.

The starer is totally non-responsive. Questions are raised and there is no reply. This person's expression is that of a brick wall. Occasionally, a ball (information) hits the wall and bounces back to its source. This person remains totally passive.

Let's hope you cannot identify with any of these listening personalities. More than likely, though, you know some of these individuals.

Being an effective listener (and learner) is like eating. As the listener, you take in information (the food). You absorb or assimilate this information into your thinking processes and give it meaning (digestion). You then respond to this digested information by exhibiting a new work skill or taking action on some project.

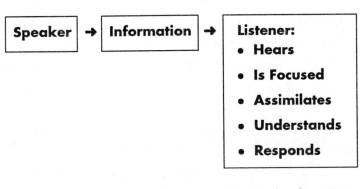

Generally, if you do not perform the functions listed above, communication is lost and little if any effective listening occurs. As an adult learner and listener, it is important to understand these listening functions, so that you can identify any obstacles and make changes or corrections in your learning profile.

Hearing. Receiving the auditory stimulus is the first step toward becoming an effective listener. It's the first step in the communication process. Barring any physiological problems, the process of hearing is more or less a given. However, once the information is heard (received), effective listening begins if the individual is focused, assimilates and understands the information, then responds accordingly.

Focus means paying attention and concentrating. Lack of attention or concentration is probably the most detrimental barrier to effective listening (and learning). The Daydreamer certainly would not be very focused on the information being received. Usually, the Daydreamer is easily distracted. He may drift in and out, and will occasionally pick up a few fragmented bits and pieces of information.

The Daydreamer needs to analyze his behavior. Why is there little or no focus? Why is this person so

easily distracted? Following are some possible answers to these questions.

Personal problems: The adult listener and learner frequently has an overloaded and overburdened mind. There are problems with bills, spouses, children and work. Often, it is simply difficult to block out all of these distractions. Accordingly, this person drifts in and out of the communication process. The listener's agenda is more relevant than the speaker's message and thus, the listener's mind is elsewhere.

No interest: The listener has no interest in the message being transmitted. The next time you're in church, look around at the congregation during the sermon. How many heads are bobbing? How many passive, blank stares do you see?

Now take a look around the room when your company holds a meeting that all key personnel must attend. Like church, you may see a head or two bobbing. You definitely will detect some blank faces. You also probably will see one or two individuals doodling, whispering, etc.

Whether it is church or the corporate meeting room, the message must grab the listener's interest. Our minds crave stimulation. If the speaker's information doesn't attract our interest, our mind will find some other stimulation—problems with the kids or the boss, planning our next vacation, purchasing a new car, etc.

Lack of interest is often a two-way problem. Often, the listener lacks interest because the speaker has failed to capture the individual's attention. Note that the minister may frequently begin the sermon with a

joke or some humor to "wake everyone up"—to get their interest.

Selective Listening: Often a person is a critical listener. For example, as a manager in a large corporation, you must attend a meeting conducted by the human resource department regarding the implementation of a new employee benefit package. You go to the meeting with a negative attitude, thinking that the company is going to stick it to you again.

As the meeting begins, your focus is on how this new employee benefit package will affect you. Accordingly, you selectively listen to those parts of the presentation that serve your interests. You receive a fragmented message. You pay little or no attention to those elements of the presentation that do not directly affect you.

Assimilation and **understanding** refer to the process of classifying and systematically organizing information, which leads to interpretation, retention and comprehension. Like a computer, our minds automatically organize and classify information. This process occurs because of our mental filtration system, which enables information to be separated and organized.

This filtering process is based on our prior experiences, learning, personal needs and motivations. For example, if you went to church last Sunday and you also listened to all of last Sunday's football scores, could you summarize last Sunday's sermon? Could you tell us who won all of the football games, and possibly the scores of most of those games?

The Filtering
Process

If you're a football fan, you'll remember the football scores. If you're not a football fan, possibly you'll remember some of the sermon. Your filtering system retains what it is motivated to keep and throws out that which doesn't serve your needs.

Consider, the process of making coffee. It consists of a solid (the coffee), a liquid (the water) and a coffee filter. The purpose of the filter is to allow the water to pass through the coffee and into the pot without the coffee grounds also ending up in the pot. The filter also will separate or block out any dirt or impurities.

As we listen to information, our mental filters will classify information, allow some information to pass through and/or block out certain information. Some of our listening mechanisms for filtering information consist of the following:

- Past listening or learning experiences

- Personal attitude and feelings

- Attention and concentration

- Personal motivations

- Emotional expectations

- Perceptions and preparation to receive the information

- Prior knowledge of the information being transmitted

For example, if you are attending a lecture on economics and, while in college, you failed an economics course, automatically this information will be filtered into the "I couldn't care less" cells of your brain. On

the other hand, if you majored in economics while in college, this lecture will be filtered in a different way. Thus, learning, retention and comprehension will depend on how this information is passed through the brain.

In addition to this filtering process, there are some external factors that also will affect our ability to assimilate and comprehend information. One such factor is the speaker.

If the speaker physically reminds you of your high school algebra teacher and you positively hated algebra, you may be inclined to "hate" this speaker before he utters the first word. Your filters won't let the message through, just as the coffee filter doesn't let the coffee grounds through.

If the speaker delivers his message in a monotone, without any emotion or facial expression, emotionally you as a listener probably will not be too involved. "He's putting me to sleep!" How many times do we leave church, a lecture, a training session uttering the words, "He's not a very good speaker." What we're saying is our emotional or personal expectations have not been satisfied. For the most part, the speaker's message was filtered out.

If the speaker has some annoying habit, such as jingling change in his pocket or looking over the top of his glasses, you can become so focused on the annoying habit that you fail to comprehend the message.

On the other hand, if the speaker's lecture deals with subject matter you are familiar with, if it meets your expectations, you will listen differently. Your

mind will filter this information in such a way that comprehension and retention are almost assured.

Once the information has been filtered or assimilated, understanding should follow. Understanding may entail reviewing the information, asking questions, evaluating the data and finally reaching a conclusion.

An effective listener asks questions of the speaker to clarify understanding. Good listeners review and analyze the information. Good listeners are not "Jumpers"—they will not form a conclusion until all information has been received, reviewed and evaluated.

Responding to the information given by the speaker usually takes the form of some visible reaction. The listener nods his head and smiles, acknowledging (for the speaker) that the message is received and understood. Conversely, a shrug of the shoulders and a frown by the listener may indicate confusion and lack of understanding.

A positive response can also be given when the listener (learner) exhibits a new work-related skill because of a training session. Affirmation of the training received in the learning session may take the form of improved telephone skills, dealing more effectively with unhappy customers or demonstrating more effective use of the computer.

If the purpose of the lecture or training session was preparation for taking a test, then receiving a passing score on the exam also would indicate a positive response.

As adult learners, we need to be effective listeners.
Effective listening skills enable us to become survivors
in the work environment and facilitate the learning
process.

Effective listening is a learned behavior or skill. It
is an active process, which requires that you under-
stand how you listen. For this reason, you should
identify your listening profile.

Good listeners hear a message, are focused, assimi-
late the information for understanding and respond
accordingly. The process of staying focused refers to
the ability to identify distractions, which become bar-
riers to effective listening, and eliminate them.

Assimilation and understanding are the mecha-
nisms by which information received is filtered accord-
ing to our prior experiences, current motivations, be-
haviors and personal needs, which leads to a response
to the message received.

Response is evidenced by displaying a new job skill,
being promoted or passing an exam. Generally, the
response affirms that the message was delivered and
effective listening occurred.

Summary

CHAPTER

6

Improving Your
Listening Skills

The previous chapter outlined how we listen and the requirements for effective listening. Most of us have the physical ability to hear. The machinery is in place.

However, listening is like your lawn mower. You only use the lawn mower three or four months of the year (in a northern climate), and it lies dormant for the balance of the year. In the spring, when you start it up for another season, often you have to coax it a bit to get it going.

We listen by means of the physical process of hearing. The hearing mechanism is in place, but if we haven't practiced listening, we may need to coax or train ourselves to become effective listeners. The good news is, even if you haven't developed or used your listening skills properly, they can still be rescued and put to proper use.

If you feel that you are lacking the necessary skills to be an effective listener, there are certain steps you can take to improve this situation. By improving your listening skills, you also enhance your learning abilities. In addition, you will be a more valued employee in accordance with the new employment contract.

Your listening skills can be rescued and revived,

Three More
R's—Rescue,
Revival and
Renewal

which should provide you with a renewed interest in the skills of listening and adult learning.

The first step in this rescue and revival begins with understanding yourself, your motivations and how you presently listen with regard to:

| Focus + Assimilation + Understanding + Response |

Focus As you've learned, focus refers to your ability to concentrate and pay attention. To improve your focus requires that you first identify your distractions. You may want to establish a distraction checklist, which would include those things that cause you to lose your concentration and stop paying attention.

The purpose of this checklist is to make you aware of various distractions and their impact on your ability to listen effectively. By becoming focused on your distractions prior to a listening situation, you may be better able to stay focused on the speaker's presentation. In other words, consider your potential distractions prior to listening, rather than after you are forced to listen.

Distraction Checklist

Using this 1-to-5 scale, rate each of the following situations on its ability to distract you.

1	2	3	4	5
Minimum Distraction		Moderate Distraction		Major Distraction

1. Internal personal problems that affect concentration.

2. A prior negative experience with the speaker.

3. A speaker with a heavy foreign or regional accent.

4. A noisy environment.

5. A speaking topic that is of little interest to you.

6. An extremely pleasant-looking speaker.

7. An extremely unpleasant-looking speaker.

8. An uncomfortable room—too hot, too cold, poor lighting, etc.

9. A speaker or speech that is poorly organized.

10. Exhaustion and fatigue.

11. Bad time—too early in the morning, too late in the day.

12. A speaker who causes anxiety or apprehension.

13. A speech that is contrary to your attitudes and beliefs.

14. The use of profanity or vulgarity by the speaker.

Needless to say, this list of distractions could be expanded. However, it is useful in identifying the type of situations that you find very distracting.

The following suggestions should help you compensate for most of the major distractions.

Personal Problems

As previously mentioned, you bring your problem with the boss to the listening activity, your late car payment, your daughter's orthodontist expense, etc. These distractions need to take a back seat to the listening activity. One way to accomplish this difficult task is to become involved in the activity.

Passive listening opens the door for personal distractions.

Be an active listener. Get involved in the listening activity. Ask questions or take notes. Offer opinions or comments regarding the subject matter of the presentation. Distract your distractions.

Be aware that often, your personal problems cause you to lose focus, so concentrate on becoming involved in the learning process.

Speaker Problems

Frequently, the speaker can create distractions due to his or her personal appearance, speaking down to an audience, the use of profanity or being unorganized.

However, whether the speaker has long hair or

short hair, an old suit or a new suit, should not affect your ability to concentrate on the subject matter of the talk. Check out the speaker's appearance before the presentation, and then focus your attention on the content of the material—not the material in the speaker's clothing.

If the speaker has an accent and is difficult to understand, don't hesitate to ask questions for clarification. Take notes and, if necessary, seek further clarification after the presentation.

If a speaker or instructor talks over your head (i.e., uses vocabulary that you're not familiar with or becomes too technical), again you may need to ask questions. If you know that you are going to be listening to a technical presentation of some sort, prepare ahead of time by doing a little research or reading on the topic.

Some speakers use profanity and/or vulgarity for impact. If you are offended by this, you can become easily distracted. Here again, it is important to focus on the message, on the content, and not on the speaker's style.

A speaker with a disorganized presentation can be very distracting. Take notes, but space out your notes so that you can fill in additional information later. You can compare notes with others who attended the lecture. Again, it might help to be prepared before the presentation by doing some reading or research into the subject matter.

Poor lighting, temperature extremes, inadequate ventilation or an overcrowded room can become ma-

Listening Environment

jor distractions. Some of these factors you can control; others you cannot. For example, let the speaker know if the room is too hot or too cold. Perhaps the heat or the air conditioning can be adjusted. There may not be much that you can do regarding an overcrowded and uncomfortable room. You can't kick people out and get a more comfortable seat. You may simply have to force yourself into concentrating on the speaker's content—not the distractions. You need to practice a little self-discipline by ignoring the distractions and focusing on the business at hand.

Your Attitudes and Beliefs

You may have to listen to a speech that is contrary to your own ideas or beliefs. You can spend so much time concentrating on these conflicting views that you miss much of the message being transmitted.

Be flexible. Maintain your own attitudes and beliefs, but also respect or listen to an opposing viewpoint without allowing the fact that it's in opposition to your ideas to become a distraction. Compare or contrast your viewpoint with that of the speaker, but don't concentrate on blocking out the opposition.

Exhaustion and Fatigue

You should control this distraction by getting enough sleep and rest prior to attending a lecture or learning situation.

If you are mentally sharper first thing in the morning and you have the option of attending a class or lecture in the morning or afternoon, take the morning session. If you sink into a valley of fatigue by the

afternoon, do your important listening and learning in the morning, after a good night's sleep.

Think back to your college days. As you looked around the lecture hall in the morning, how many students were sitting there with their heads down, catching up on last night's missed sleep? (We won't go into why they missed their sleep the night before.) In retrospect, due to this poor preparation prior to the lecture, they probably not only didn't listen, but didn't hear either! In the real world today, you can't repeat your college activities and expect to be an effective learner or listener.

Generally, if you are prepared to listen by having adequate rest, if you have some knowledge and background regarding the subject matter, and if you become an active listener by asking questions, making comments or taking notes, your distractions should be minimal. If you become a passive listener, you probably will spend more time focused on your distractions.

A Case Study—What Not to Do

You have been exposed to some harsh realities of listening life. As adults, we usually only listen 25 percent of the time. We are easily distracted. Many of us are passive listeners, instead of active listeners. However, our ability to listen effectively enhances learning ability and may provide a degree of job security under the new employment contract.

The following scenario is provided to reinforce how you should not attempt to listen and learn. Unfortunately, many of you may be able to identify with Danny.

The Struggles of Danny

Danny, age 30, has been married for six years to Cindy. They have two children, ages 5 and 2. Danny is a middle manager in a large computer firm. During the past five years, this firm has had two reorganizations, resulting in the dismissal of nearly 100 employees, many in supervisory and management positions. In self-defense, Danny returned to college two years ago to work on his master's degree, hoping to provide a little more job security for himself and his family by making himself more valuable to the corporation.

Danny attends graduate classes four nights a week, from 6:30 until 8 p.m. He normally leaves his job at 5, rushes home, changes clothes, grabs something to eat and is out the door by 6.

Tonight, as he was rushing through his normal routine, his wife reminded him that their oldest child needed glasses, the car payment was a week late and somehow they had bounced a check.

As he was fighting traffic on his way to class, the "check engine" light kept coming on. Traffic was heavier than usual, and he arrived in class about five minutes late. He was forced to sit in the last row. This was the worst place to be, because the professor was a mumbler and had an accent, which compounded the difficulty in hearing the lecture.

To make matters even worse, tonight's lecture was on international economics—a subject Danny knows nothing about. He had taken an economics course as an undergraduate, didn't care for the subject and received a D.

Danny notices the woman sitting to his left and thinks that she is one of the people he had to lay off three years ago during the firm's second reorganiza-

tion. He also notes that one of the overhead lights is out, and the classroom feels extra warm tonight.

Nevertheless, Danny takes out his pen and note pad. Twenty minutes later, he glances down at the note pad and it's blank! He hasn't written a single word. He wonders to himself, "Where have I been for the last 20 minutes?"

Danny probably spent some time with his wife and his job. As he got settled in the class, he may have begun to wonder how a check bounced and how large of a check it was. His stomach with his half-digested dinner in it probably turned over a few times as he dwelled on the cost of glasses for his oldest child. Also, he needed to get some money in the bank to take care of the car payment.

Danny probably thought about his job and the re-organizations, due to the woman who looked like a former employee. When would the next reorganization hit? Would he be safe? If he survives the next one, what about the one after that?

Danny was especially able to play with all of these distractions due to the subject matter, as he had little interest in international economics and no positive prior experience with it. He failed to block out these distractions.

In summary, Danny "violated" many of the rules for effective listening—too many distractions, lack of preparation and he probably was fatigued. The point is that you have to work at being an effective listener. It's not easy.

Perhaps Danny should do something about the rush between 5 and 6. Maybe he could leave work a

little earlier. Possibly he should take something to eat to the campus and avoid rushing around at home.

Needless to say, he should preview the material to be lectured on prior to coming to class. He needs to focus on the content of the professor's lecture and not be distracted by his mumbling or his accent.

He needs to force himself to leave his work and family problems out of the classroom. He can do this by becoming more actively involved in listening by taking notes or possibly asking questions. A conscious effort has to be made.

Unfortunately, all of these suggestions to improve Danny's listening and learning may be easier said than done. However, if he is going to enhance his position with the firm and earn his master's degree, a concentrated effort needs to be put forth, incorporating the concepts of active, aggressive listening.

Helpful Hints—What to Do

Listening is a conscious process. It requires planning, focus, organization and commitment. Effective listening doesn't just happen. Following are some suggestions or helpful hints to help you plan for and work at effective listening.

Preparation

Reduce or eliminate distractions. Don't clutter your desk or table with unnecessary items, such as books and personal belongings. Remove from your view anything that may distract you. Place only a pad of paper and a pen on the desk. Possibly you should even consider not taking a seat near the window if the view would distract you.

Prepare for the speaker or instructor by attempting to find out something about this person. Have you ever heard him or her speak before? What type of speaker is he? Do you know others who are familiar with the speaker?

Prepare for the topic to be discussed or presented by reading or reviewing notes covering the principal subjects. Prepare for what you will listen to by knowing something about the subject matter ahead of time.

Anticipate what you hope to get from the presentation. Why are you attending this lecture? How does this lecture help meet your needs or long-range goals? How can you use this information?

Be positive. Approach the lecture or presentation with a positive attitude. Do not prejudge the speaker or the message. If you anticipate a boring speech from a dull speaker, then this is what you will hear. On the other hand, if you anticipate an outstanding presentation from an excellent speaker, you'll also get what you expect. Taking a positive attitude into the lecture hall will enhance the listening process.

If you have done all of these things, you have physically and mentally prepared the groundwork for the actual process of listening effectively.

The Listening Process

Assume a positive listening posture. Sit up straight, feet on the floor and pen in hand. Slouching or tilting the chair back does not lend itself to good note taking. Slouching can lead to drowsiness and other distractions.

Use your eyes and ears to listen. Follow the speaker with your eyes. Make eye contact. Add to your listening by paying attention to any visual aids used, such as overheads or slides.

Take notes. Your memory is limited and imperfect at best. Don't attempt to write down everything you hear. Jot down key ideas, important words or phrases. Don't be concerned about neatness, grammar or spelling. You're communicating with yourself by means of your notes. Invent your own shorthand and gimmicks. The important thing is to write the notes so that when you review your written record, you can recall and understand the speaker's message.

Stay focused. The ability to concentrate is a learned behavior. Aiming a gun at a target requires paying attention. Pulling the trigger and shooting the gun at the target requires concentration. Concentration is focused energy. You have to discipline yourself to remain focused on what you are listening to. You have to control—or at least limit—your distractions.

As mentioned earlier, if you are an average adult learner, your attention span is about 10 minutes or so. However, through planning and practice, you may be able to increase this to as much as 30 minutes at a time.

Be a total listener. Not only are you receiving communication, but you should also communicate back to the speaker. Be attentive and make good eye contact with the speaker. Acknowledge the speaker's message by nodding occasionally or smiling. By these behaviors, you are telling the speaker you understand. You're in tune with the speaker. Avoid the blank stare, looking at the clock, fidgeting in your seat. These behaviors send a message of boredom and inattentiveness. This can be a distraction for the speaker.

Control your emotions. Your emotions can block out the speaker's message. Emotional lectures or issues often make it difficult to listen effectively, since if your hot button has been pushed, you're probably missing the message. You're focused on shaking your head in disagreement with the speaker, distorting the message being delivered or simply blocking it out altogether.

Generally, our emotions are triggered to some degree when we listen to talks regarding race, religion or politics. You know best what gets you upset and excited. So the first step in controlling your emotions is to iden-

tify the issues and topics that create an emotional response in you. Emotional reactions cause objectivity to diminish. Thus, you have to be aware of those issues and topics that cause you to "lose it"—and prepare accordingly to stay in control.

Controlling mechanisms or suggestions include the following:

Take a deep breath. Emotional issues often illicit physical responses, such as increased heart rates or higher blood pressure. Taking several slow deep breaths tends to slow the heart rate and lower the blood pressure.

Use objective questions. Try to stay away from subjective questions that may result in an emotional response, which only serves to push another emotional button.

Respect the other person's opinion. Let the speaker know that you understand his or her position on the issue. You may not agree with it, but you understand and respect his or her right to have a particular opinion.

Stay calm. Don't respond or comment while upset or angry. Little can be resolved by a sudden emotional outburst.

Understand the reasons behind the issues. A reasonable rationale for a certain position or issue can reduce the level of emo-

tional involvement. Express your evidence or reasons for your position and understand the speaker's rationale. Look at both sides of the debate.

Summary

Focus, assimilation, understanding and response are the key elements for effective listening.

Focus is a concentrated effort to identify and avoid various distractions. Personal problems, problems with the speaker, emotional responses, problems with the physical environment and fatigue are all distractions. The effective listener takes positive steps to reduce or eliminate these distractions prior to and during the presentation.

Assimilation and understanding are enhanced when you take action (such as taking notes), avoid distractions during the presentation, control your emotions and provide the speaker with some positive feedback indicating that the message is being received.

In addition, effective listening is enhanced when you listen with your entire body—visually watch slides and overheads, and respond to the speaker with an occasional nod of the head or a smile.

Evidence of your effective listening will be in the form of passing an exam, improvement in a job-related skill or some other positive benefit. You will be a more effective person both on and off the job, because you have forced yourself to become a "good listener."

7

Take Notes!

One of the techniques listed for effective reading and listening was to take notes. You began writing notes probably at about age 12 or 13, while you were in junior high or middle school. However, at that time in your life, you were *writing notes to* someone.

As an adult learner, you need to have the ability to *take notes from* someone or something. You need to be able to hear someone speak or read material and extract relevant data and information from this communication.

Before you begin a note-taking assignment, it is important that you set the table first—be prepared ahead of the main course, the speaker. If this is a classroom situation, prepare for the discussion or lecture before you come to class. Preview, read and review necessary material. Familiarity with the topic and concepts will allow you to identify important information quickly and easily.

If you don't prepare by previewing the topic or material to be covered, you may tend to think that everything coming from the speaker's mouth is important. You can't possibly write down everything

Set the Table First

that you hear. Being properly prepared makes note taking easier and more meaningful.

If your note taking is to occur based on a verbal presentation, remember some of the listening skills that were reviewed earlier—principally, reducing distractions. Distractions can distort what you hear and, consequently, the notes you are able to make.

Therefore, arrive a little early for the presentation and pick a seat near the front of the room, where you can easily hear the speaker and also see the blackboard or any overhead used by the speaker. Also, if you feel that you would be distracted by sitting near a window or a door, select a seat away from these potential distractions.

Finally, make sure you are prepared to take notes by having an adequate supply of paper and more than one pen or pencil. If, halfway through the presentation, your pen runs dry and you don't have another, you may be out of luck. It is amazing how people can attend a class or lecture and at the last minute be running around trying to find paper or borrow a pencil. Come prepared.

Writing to Others

Writing notes (or letters) to someone is typically a slow, methodical process. You have the luxury of time to compose your thoughts and select the right words to use. Generally, your attention and concentration are on one matter—placing words on paper to convey a message to someone. Since the other party has to be able to read your letter, you're probably being as neat and precise as you can in terms of spelling, punctuation and grammar.

Taking notes based on reading material also provides you with the luxury of time. You can read at your own pace. You can be neat. You can write very legibly.

On the other hand, as you sit there and listen to a lecture, speed and accuracy are important. Although you may sometimes feel like doing it, you normally don't tell the speaker to stop or slow down. In this situation, you are basically communicating with yourself. Therefore, you have the luxury of being as sloppy as you wish. You're the only one who has to read or understand the information.

Invent your own shorthand. Abbreviate words and phrases to conserve time as you take notes. For example, if you are listening to a lecture on Social Security, write Social Security as "SS." If you want to write "organizational objectives," you could certainly reduce these words to, "Org. Obj." You will understand this, and it doesn't usually matter if anyone else can read your "shorthand."

How you take notes may be influenced by the purpose being served through your note taking. If you're being entertained by a comedian, you may take a few scattered notes to help you remember a joke or funny line. If you're preparing for your final exam in economics, you may write pages and pages of very detailed notes.

In either situation, note taking requires that you take notes on the right stuff. This takes us back to Chapter 4, where you had some practice identifying topic sentences and definitions. Note taking requires

Writing to Yourself

that you be able to extract what is important and relevant and—just as important—ignore the irrelevant. This is particularly true if your ultimate goal is to pass a test or prove a point to someone.

Note-Taking Exercise

To provide you with a little practice in identifying the "right stuff," read each of the following paragraphs, including the instructions that precede each paragraph. Then, using your own words, write the main thoughts or principal ideas for the paragraph in your notebook or on a sheet of paper. This may or may not be the topic sentence of each paragraph. Feel free to abbreviate or use your own version of shorthand.

Paragraph 1

You are listening to a panel discussion regarding the presidency of Abraham Lincoln as part of an American history course you are taking. You eventually will participate in an open discussion of the 16th president of the United States, based on the panel's discussion.

"The Civil War began when Fort Sumter was fired on by Confederate troops in the spring of 1861. Fort Sumter is situated in the harbor of Charleston, South Carolina, where it remains today as a national monument. When the war ended in April 1865, a tribute to both the North and the South was planned for Fort Sumter. A prominent northern politician was invited to these ceremonies, but had to decline the invitation because he and his

wife were to attend a play at Ford's Theater in Washington, D.C. Abraham Lincoln sent a representative in his place to Fort Sumter and attended Ford's Theater instead. Had President Lincoln attended the ceremonies at Fort Sumter, perhaps the history of the post–Civil War South would have been different.

You are preparing for your final exam covering the history of the Civil War by attending the last class of the semester, two days before your test.

Paragraph 2

"The cause of the Civil War was economic. The North threatened the abolishment of slavery. The South viewed this movement as an attempt to destroy their economic way of life and their very culture. Doing away with slavery would bring economic ruin to the South, as an entire institution would be destroyed and, in the process, a way of life and living also would be destroyed. The South's economic survival was at risk. Attempts at political compromise had not worked. Finally, the election of Abraham Lincoln as the 16th president of the United States was the final insult. In the spring of 1861, Confederate troops opened fire on Fort Sumter in Charleston harbor. Thus began the bloodiest war in American history."

Paragraph 1: Here, your need is for information to help you with a later discussion regarding Abraham Lincoln. Primarily, you should be concentrating on Abraham Lincoln. Secondarily, since the Civil War is closely related to President Lincoln, information regarding the war may be helpful, also.

Thus, the principal thought or idea in this paragraph should probably be a note with reference to the impact of Lincoln's assassination on the post–Civil War South. How might history have been different if Lincoln had attended the ceremony at Fort Sumter instead of the play at Ford's Theater?

The start and end of the Civil War are not as important as the impact of Lincoln's death, in the context of the subsequent discussion about Lincoln.

Thus, you may have written your notes as:

"AL death, changed hist."

Paragraph 2: Here your focus is broader, or more general. You are preparing for a final exam covering the Civil War, not simply an open discussion about one historical figure from that war. Therefore, your notes need to be broader.

The economic cause of the war is a major concept. Failure to resolve the issue by compromise and the election of Lincoln led directly to the war, which began in the spring of 1861.

Your notes may have been written as:

"Cause of war—econ. Threat to abol. slavery & election of AL = war—Ft. Sumter, SC, spring 1861."

Whether you are reading material or listening with pen in hand, your first goal is to identify what is important relative to the context in which you are taking the notes. You cannot take notes on everything you see or hear. You may pick and choose your material when reading.

In general, when taking notes based on a speaker's presentation, you should:

- Identify your purpose for the notes (general information, test preparation, etc.).

- Employ good listening skills and listen for key ideas, words or phrases, definitions, etc.

- Make notes on visuals. Generally, anything that a speaker writes on the board or illustrates by an overhead or slide projector should be considered important.

- Place key ideas or major thoughts at the margin of your paper. Indent those items of secondary importance beneath key ideas. Thus, a key point is flush with the margin and minor points are indented (outline format).

- Use symbols, pictures, diagrams and graphics in your notes. Often, relevant information is more easily retained by using mental pictures.

- Write in "shorthand" and don't worry about neatness or correct spelling or grammar.

- Tune in to the speaker's voice changes, pauses and increased volume, as often these serve as verbal cues for important facts and ideas.

- Maintain eye contact with the speaker, as certain gestures and movements may indicate an important point.

- Listen for repeats. If a point is subject to repetition, that's probably because it's important. Repetition aids retention. If the speaker repeats, you should probably repeat it in your notes, as well.

- Don't hesitate to ask questions for clarification, or ask for an example to help make a point more meaningful. Then record the example as part of your notes.

Create Your Own Shorthand

Because speed in note taking may be required, it is important to be both precise and quick. If you're still writing what the speaker said two minutes ago, you've missed two minutes of the presentation. Thus, out of necessity, you may have to create your own abbreviations or shorthand. Remember, you're communicating with yourself, so use symbols or letters that convey the information to you.

Following are some suggestions for your "shorthand":

President	Pres.	Because	Bec.
Government	Govt.	That is	i.e.
Attorney	Att.	The same as, like	=
Regulation	Reg.	By means of	per

Increase	Incr.	Including	Incl.
Definition	Def.	Cease and Desist	C&D
Important	Impt.	Without	wo
Individual	Indiv.	Computer Terminal	CT
Regarding	Re.	Transportation	Trans.
Discussion	Disc.	Morning or Evening	AM/PM

Using this short list, if you heard the speaker say, "The president will issue a cease and desist order regarding transportation policies without any further discussion," you could possibly shorten this to:

Pres issue C&D order re trans pol wo disc.

The important thing is that when you review your notes, you can read this abbreviated sentence and understand its meaning. If you invent a form of shorthand and then later cannot read or understand what you wrote, you'll be lost.

Let's try some more. Abbreviate the following sentences in any way you choose. There is a suggested abbreviation, but this doesn't mean it is the "right one." The right one is the one that communicates meaning to you.

1. The computer terminals must be turned off every evening at 6 o'clock.

2. The cost of your hospitalization insurance will be reduced by increasing the deductible.

3. The last war the United States was involved in was World War II. Since then, the other conflicts might be called acts of war.

4. The government may increase Social Security benefits by means of increased Social Security taxes.

Increased taxes are an important consideration for every senior citizen.

5. People buy life insurance to protect against the risk of premature death. They purchase annuities to protect against the risk of living too long. It is estimated that by the year 2045, there will be more than 1 million people age 100 or older. We are living longer due to medical advances and healthier lifestyles. For example, fewer people smoke today and, generally, all of us are diet- and exercise-conscious.

Ideally, you were able to shorten or abbreviate this information into concise, meaningful notes. Following are some suggested notes for this information.

1. The computer terminals must be turned off every evening at 6 o'clock.

CT off 6 PM ea. nite.

2. The cost of your hospitalization insurance will be reduced by increasing your deductible.

Hosp. cost ↓ by ↑ ded.

3. The last war the United States was involved in was World War II. Since then, the other conflicts might be called acts of war.

Last US war = WW II. Others = acts of war.

4. The government may increase Social Security benefits by means of increased Social Security taxes. Increased taxes are an important consideration for every senior citizen.

↑ SS ben. per ↑ SS taxes. Import. for seniors.

5. People buy life insurance to protect against the risk of premature death. They purchase annuities to protect against the risk of living too long. It is estimated that by the year 2045, there will be more than 1 million people age 100 or older. We are living longer due to medical advances and healthier lifestyles. For example, fewer people smoke today and, generally, all of us are diet- and exercise-conscious.

Life Ins. - risk premature death. Annuities - risk living too long. 2045 - 1 mil. age 100+. Reasons = med. adv, fewer smoke, diet & ex.

Review Your Notes

Again, the important factor is whether or not, at a later time, you are able to reread your notes with comprehension. The "later date" should be as soon as possible after you have taken your notes.

Do not wait several days or a week to review your notes. When writing your notes very quickly, there may be some words that are actually scribbled. If a week passes before you attempt to read your notes, you may not be able to understand some of your own scribble.

Therefore, it is best to review your notes the same day, while the speaker's words are still swimming in your head and while your scribble may still have meaning. You may wish to clarify or rewrite some of your notes at that time.

Summary

As an adult learner, a very useful skill is the ability to make a record of what you hear or read—note taking. Effective note taking requires that you prepare for the assignment by understanding your motivations or reasons for taking notes—exam preparation, learning a new job skill, general information, etc.

A good note taker also will prepare by eliminating distractions and staying focused on the speaker. This means also eliminating any physical distractions, such as sitting near a window or at the back of the room where you find it difficult to hear or see. Lastly, being prepared means you have something to write with and to write on—a good supply of paper and two or more pens or pencils.

Effective note taking results in self-communication. You are writing or talking to yourself. You are probably the only person who will ever read your notes. Therefore, don't be concerned about neatness, spelling or grammar. Use whatever words, symbols and pictures will result in effective communication.

Notes highlight important information and pay less attention to less important information. Therefore, you need to know how to identify important or relevant information. Listen to the speaker's voice inflections or volume. Often, these speaking mannerisms denote key concepts or ideas.

Generally, if the instructor writes information on the blackboard or creates some graphic or visual, it's probably important, and thus it should be included in your notes. Don't hesitate to ask questions of the speaker for clarification of relevant information. Remember, you can't write everything you hear. You must have the ability to select what is important.

To keep up with the speaker requires that you have your own version of shorthand. Use abbreviations. Be concise, but also be accurate when writing notes. To ensure accuracy, review your notes as soon as possible after writing them.

Math Panic

2x + y(3x - 2y) = HELP!

If you don't know how to find the answer to the above equation, you're not alone. Many of us have "mental blocks" when it comes to mathematics.

You may be good at basic addition, subtraction, multiplication and division, but a fog clouds your mind if you're asked to find the answer to $2x + 2x = 16$. Unfortunately, your mental fog probably first appeared way back when you were in the early years of learning mathematics.

The purpose of this chapter is not to teach you how to become an expert mathematician. This chapter will provide you with some basic tips or study skills so that if you are forced into a learning situation that involves math, you will be able to approach this endeavor with less apprehension and a more positive attitude.

The One-Gallon Jug

During your early formal education, you had a one-gallon jug that was labeled "Mathematics." This jug represented your capacity to learn and understand math. When you finished your formal education sev-

eral years later, the one-gallon jug contained a half-pint of knowledge. The rest of it was empty. You may have known individuals whose jug was filled to overflowing. (They grew up to be actuaries, CPAs, engineers, mathematicians or the Unabomber.) Many of us, however, never came close to filling up the jug.

This analogy brings home the fact that most of us were (and many are) capable of better mathematical understanding and ability. Mathematical skill levels for many of us are simply not up to the skill levels we enjoy in other academic areas. We may be excellent readers, outstanding spellers and great at English grammar, but we are terrible when it comes to math!

As an early learner in elementary school, much of the learning activity involved the use of vision, hearing and touch. You had an excellent memory. You were able to remember your colors, certain words and the spelling of your name. You could also count from 1 to 100.

The problem that probably occurred in the development of your mathematical ability was the requirement that you had to think about math. You had to reason and ponder the relationships between numbers. You were forced to deal with theorems and formulas. In the early years of your formal education, it may well have happened that you were told or taught what to think, but not how to think.

You were forced to use a new tool (your mind) and to perform a new function (mathematical thinking). This is not to imply that you were a non-thinking vegetable as a young learner. It's just that now you had to think about relationships and equations, and

you had to think at a different level using your mind in a new, unfamiliar manner. And you began to fall behind, especially when "arithmetic" turned into fractions, percentages, formulas and algebraic equations.

Aptitude and attitude are first cousins. They are closely related in that they are dependent on each other and influenced by each other.

Aptitude and Attitude

**Aptitude =
Ability and Talent to Learn and Understand**

**Attitude =
Opinion or Disposition Toward Learning**

Your mathematical aptitude is the one-gallon jug—your innate ability or talent to learn and comprehend math. To a degree, how well you use this talent is determined by your attitude or disposition toward mathematics.

Approach the task of learning math with a very positive attitude and you will more easily fill the gallon jug. You will more easily attain your potential. Approach the assignment to learn some math with a negative attitude and you will probably experience great difficulty.

Needless to say, a positive attitude is the key that unlocks a lot of potential in all of us, whether it is academic learning, improving your listening skills or acquiring a new job-related skill. Believe that you can learn math and you will learn it, because you probably have the aptitude to do so. Don't believe in yourself and it will be a struggle.

> **Maintain a positive attitude to reach your potential.**

Believe— Then Do It!

Believe in yourself. Believe that you have the aptitude. This belief creates a positive attitude. Then work at it. Do it and achieve your goal. The first study tip to improve your math study skills is to maintain a positive attitude.

Many adult learners have had negative learning experiences with regard to math. When faced with the challenge of learning or dealing with math, the immediate reaction is, "I can't do that. It's math!" The task is approached with a negative attitude. When the adult learner fails at the task of learning some math, he or she quickly responds, "I told you so."

Pavlov's dog salivated every time it heard the bell ring. It was an automatic response over which the dog had no control. When you're watching a baseball game and a batter hits a hard foul ball into the seats, everyone ducks. It's an automatic response. When you kiss, you close your eyes (at least most people do). It, too, is an automatic response.

These automatic responses are generally involuntary. We do not consciously elect to close our eyes or duck to avoid being hit by the foul ball. However, you do have a choice when it comes to learning something perceived to be unpleasant, such as math.

Too many of us simply give up—surrender—before the first shot is fired. Yet, you have control. You can elect to persevere, or you can choose to quit before you even get started.

> **Successful people do the things unsuccessful people refuse to do.**

Belief in your abilities and a positive attitude will result in success.

The Basics

Once you've laid the foundation by means of your positive attitude, you then need to follow some basic study guidelines. Generally, these guidelines are suggested for the individual who has the gallon jug filled with a half-pint of knowledge.

Note taking. Again, it's recommended that you take notes to improve your listening and retention of information. However, what you need to take notes on is the math problem being presented on the board or on the overhead projector, as well as the instructor's explanation as to how the problem is solved. Taking notes based on the words you hear is insufficient without being able to relate the explanation to the problem. So, basically your note taking involves words and numbers. If you find that this is too difficult in terms of time, then you may want to consider using a tape recorder (with the instructor's permission), so that your notetaking is confined to copying numbers and problems.

Be precise. Math is an exact science. Therefore you shouldn't abbreviate or paraphrase information. Be exact. Math sometimes uses theorems, laws or rules. Copy these exactly. Don't leave anything to chance. You may abbreviate or shorten words or phrases when taking notes regarding the Civil War. This same meth-

odology doesn't work well when dealing with an exact science like math.

Practice makes perfect. Once you have grasped a mathematical concept, practice and work with it. Do extra problems as reinforcement for what you've learned. Remembering that World War II began in 1941 for the United States can be "mastered" quickly. Learning how to work compounding interest problems may take several days of practice. You can't work one problem correctly and believe that you've mastered the concept. Practice, practice, practice until you are perfect.

Plan your work and work your plan. Procrastination is the enemy of all good deeds left undone. If math is not your favorite pastime and you've experienced many negative learning situations, you are going to have to force yourself to overcome these problems by making sure you spend the necessary time to achieve some success.

Look at your work schedule, your recreation time and your family time, and you will find pockets of time in which you have "nothing to do." Identify these time slots and write down day and time that you will spend working with your least favorite subject—math. When the allotted day and time arrives, work on your math—don't mow the lawn, catch up on housework or watch TV. Plan your work and work your plan to achieve success.

Test and check. Test yourself by working math problems (remember, practice makes perfect). Correct your problems. Once corrected, do not sit back and say to yourself, "I did pretty well. I got eight out of 10

correct." Rather, ask yourself, "Why did I miss those problems? What did I do wrong?" Learn from your mistakes. Also, you can learn from your successes. Ask yourself, "Why did I get those problems correct? What did I do right?"

When working with math, you should always recheck your answers. Recheck your thinking process.

Avoid dumb mistakes. When we say to avoid dumb mistakes, we mean careless mistakes. For example, you knew that you were supposed to add; instead, you subtracted. Carelessness. You "eyeballed" a problem. You did it in your head and made a simple mistake—a mistake you wouldn't have made if you had used paper and pencil or a calculator. Reduce the number of careless math mistakes and you will increase your competency and skill level.

If you rely heavily on a calculator, then use the calculator. Don't take shortcuts that can result in careless mistakes. Most of us have been brought up on calculators. We can't think mathematically unless our fingers are pushing buttons. So be it. Use the calculator, but be careful: You can still make a careless mistake by hitting the wrong button!

Ask for help. Don't be afraid or embarrassed to ask for help. Einstein asked for help. So can you. Seek out a person who has filled up the math jug. This might be your own son or daughter. Don't be ashamed to ask.

Often, formal instruction may not be as effective as peer instruction. You and your math instructor may not be tuned in to each other. The instruction may be "over your head." You may not understand the full

message. Often, a peer can take the same problem and explain it in easy-to-understand terminology and the fog is lifted.

I once observed a 15-year-old girl attempting to teach some soccer skills to a small group of 4-year-old boys. One of the 4-year-olds touched the soccer ball with his hands. The young instructor said, "That will cost you a lap." The 4-year-old violator replied, "What's a lap?"—to which another 4-year-old answered, "You've gotta run around the gym once." Peer instruction often provides the missing meaning and understanding.

Refresh Yourself

In addition to seeking help from peers, don't hesitate to get some remedial help. Find a local high school or community college that offers adult courses. If it's been 20 years since you took business math, and now your boss tells you that you must complete some level of work-related training that involves considerable use of business math, go back to school. Take a business math course. It will serve as a refresher and help you to approach the work-related training course more comfortably and with a more positive attitude.

Summary

Many of us have weak math foundations and lack positive learning experiences regarding mathematics. Achieving an acceptable mathematical skill level starts with a positive attitude.

Many of us have never used our mathematical talents to their fullest. We probably still have the aptitude, but a positive attitude must be added to our innate abilities.

Effective mastery of math or math skills is largely a state of mind. Once the state of mind is set, we can then utilize certain "mechanical tools" to increase our math skill levels. These tools include precise and accurate note taking, practice and more practice, in-depth testing and checking, avoiding careless mistakes and seeking help from available resources.

9

Whoops! I Forgot

As a young child, when you didn't hang up your clothes, clean your room or do your homework, your favorite excuse was "I forgot."

Now that you are no longer a child and have given up the things of a child, when your boss asks you if this month's report has been sent to your main office, you reply, "I forgot." However, you normally qualify your forgetfulness by prefacing this universal excuse with, "My 3-year-old was up all night with an earache. I'm sorry, I forgot."

Your Brain's Capacity

Your brain is not like a balloon that you keep filling with air and suddenly it explodes because there's no more room. Your brain has an unlimited capacity to store information.

Your brain and your memory are different but closely related. Your brain receives and stores information. It's like an enormous, yet compact, computer. Memory recalls the stored information. Your brain is the command post and is the primary organ of your central nervous system. Memory, an activity of the brain, recalls to our conscious mind facts or experi-

ences stored in various parts of the brain in millions upon millions of brain cells.

Your brain cannot and does not run out of room. It has the capacity to process and store information essentially without limitation. By way of disease, brain cells can be destroyed. Depending on the cause of such a loss, brain cells also can be rejuvenated or retrained. Our brains contain hundreds of millions of brain cells, so even if you lose a million or so, your brain will continue to function. As a lifelong adult learner, your brain will not run of space, for all practical purposes, and your memory will usually continue to function.

Actually, studies show the more you use your brain, the better it functions. Just as atrophy can cause our muscles to grow weak and useless, so too can our brains (and memory) not function as well due to disuse.

Much of the information that comes into your brain is connected to other similar bits of information and experiences already stored in your brain. The more connections we can make, the easier it is to remember information. For example, a person who has a degree with a major in history can probably recall historical facts and information easily, because each bit of information is connected or built on other historical information stored in the brain.

Conversely, a person with a major in math may find it more difficult to recall historical facts and information, because there are fewer such connections.

Memory can be broken down into short-term and long-term memory. New information is temporarily stored in the short-term memory room, awaiting per-

manent storage in the long-term memory bank. Frequently, we forget what's stored in our short-term memory. It's lost before it becomes part of our long-term memory.

This helps to explain why you are able to clearly remember something from your childhood, but you have difficulty remembering something that happened last week or last month.

Something has to be done to reinforce short-term memory information so it is successfully converted into long-term memory.

The Memory Machine

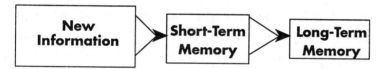

"I'm getting old" is a common remark made by individuals who have difficulty remembering their own telephone numbers, their spouse's birthday or other pieces of information. There are certain changes that do occur relative to age. However, generally your memory, your ability to recall the brain's stored information, is not as affected by age as we believe.

On the other hand, your ability to learn can be affected indirectly by age. However, you can help compensate for this by having knowledge of certain aging factors.

For example, if your vision is not as good as it once was or your hearing is not as sharp as it used to be, your ability to learn can be affected. This is especially

I'm Getting
Old

true when we consider that most of us are visual or auditory learners. Our brain is still functional. Our memory will still recall. It's our learning mechanisms—sight and hearing—that have let us down. Naturally, you can compensate for these physical weaknesses by wearing glasses and/or hearing aids.

Our mental health is often directly related to our physical health. Exercise, rest and a proper diet are as important at age 72 as they were at age 7. Generally, if we feel good physically, we feel good mentally.

Retention (memory) for an older person is as good as it is for younger individuals, provided the subject matter is relevant and interesting. Young or old learners will not easily remember dull, boring information. The problem faced by the older person is that they have seen it, done it, experienced it. Accordingly, what others perceive as new and exciting might seem old and monotonous for a senior citizen, who will therefore find it more difficult to retain and recall the same information.

For example, recall what your "spouse to be" was doing and wearing the very first time you met. Regardless of your age, you can probably remember this easily. On the other hand, if you have been married for 35 years, you may not remember what your spouse was wearing this morning when you left the house. You may momentarily forget your own phone number because you never call yourself. You remembered your spouse's birthday every year for a while. Then there were the children's birthdays to remember, then the grandchildren's. Today, you still remember your spouse's birthday. It simply takes a little longer because other birthdays have also become important.

Usually, for those over age 50, the speed at which you can recall information slows down a bit. All this means is that it may take a 60-year-old a few seconds longer to respond to a question or recall something as simple as a telephone number.

Most likely, if you received an A for the last history course you took in college 35 years ago, you can still take a college history course today and earn an A. The ability is still there.

However, if you were one of the first to complete the final history exam in college, at age 55 you may be one of the last to complete the same exam. But you can still earn an A.

The adage that you are never too old to learn is true. Your brain is still functional, even though your auditory or visual mechanism may have detriorated a bit. Your ability to recall information is still there, too. It may simply have slowed down by a few seconds with age.

As an adult learner, you can stay sharp, learn and have a good memory. You may simply have to coax or massage your memory a little more.

Getting More Out of Your Memory

Depending on the elementary and secondary school system where you spent the first 12 years of your formal education, evidence of learning may have been equated with memory. Memorization of facts, places, dates and formulas seemed to mean you were learning and well educated 30, 40 or 50 years ago. The ability to successfully memorize facts may still be evidence that learning has taken place in some educational circles.

Your brain stored the dates and facts, i.e., the Battle of Hastings in 1066; the discovery of America in 1492; the attack on Pearl Harbor, December 7, 1941; Abraham Lincoln, the first Republican president; John Kennedy, the first Roman Catholic president; etc. You were then tested on this stored information and earned an A because your memory was able to recall the correct facts. So—presto—learning had taken place. But there are educators who would disagree with this conclusion.

You received an A because your memory was functioning properly. So you actually got an A in memory, but it was called "History" on your report card. If your test question had been, "What is the significance of Abraham Lincoln being elected the first Republican president?" instead of "Who was the first Republican president?" you may not have received the A.

The ability to quickly and accurately recall facts and figures may serve you well if you ever go on a game show, but it doesn't necessarily mean that any profound learning has taken place. Nevertheless, memory is a vital part of learning. We are forced to memorize certain facts and information. Therefore, you can improve your total learning ability by taking care of your recall mechanism.

A paradox of memory is that at the same time you begin to learn something new, you begin to forget it. Learning and forgetting go hand in hand. New information is forgotten quickly. It is estimated that 70 to 80 percent of new information is forgotten within one month.

Generally, we are only able to recall 10 percent or

less of the information stored in our long-term memory. The information is there. It's just that we can't recall it. Much of our new information loss occurs within a day or two of acquiring the information.

Your memory can be trained, improved, enhanced, massaged and cultivated, though. Your forgetfulness can be minimized. Your ability to be a successful adult learner can be enhanced through memory training. The following pages describe some memory training techniques—ways of massaging your memory to get the most out of it.

To prevent a loss of new information, review the material immediately. Review your notes briefly within 30 minutes or so following the class or presentation. This quick review serves to reinforce the newly acquired information in your short-term memory.

Immediate Review

Thus, if you have four pages of notes following a one-hour lecture, simply reread your notes as soon as possible. Don't attempt to memorize them or spend a long period of time studying them. Your goal is simply to briefly review the key concepts and ideas shortly after the information has been received.

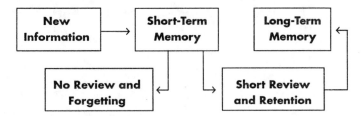

The short reinforcing review enables much of the new information to eventually be retained in long-term memory. Skipping the short-term review of new information frequently results in loss—"I forgot."

Pace Yourself

If you were running a marathon and your goal was to finish the race, you would pace yourself so that you would not "run out of gas" early on. The same principal applies when you are studying and learning. You should pace yourself by studying in small doses.

Your retention will be improved if you study for small periods of time, such as 20 minutes, followed by a short three- to five-minute break and another 20-minute study session. For example, if your goal is to study for one hour, your retention will be improved if you break this down into three 15- to 20-minute periods with short breaks between study periods.

The reason for this is the typical adult learner has an attention span of about 10 to 20 minutes. If you're average, you can probably stay fairly well focused for about 15 minutes. If you're a little better than average, you may be able to "tolerate" about 20 minutes. After 20 minutes, you probably aren't sure if you're staring at the study material or if it's staring at you. That's why spacing your study time apart in small segments is better than spending one or two continuous hours.

Grouping

You may need to consider grouping the subject matter to be learned or retained. For example, if you are preparing for a test that requires recall of specific

information, like dates and numbers, grouping this type of information into small bits will aid your memory.

Let's assume that you have 12 sets of numbers and 12 dates to remember for your test. Rather than sit down with a total of 24 bits of specific information, group this data into smaller bite-size bits—e.g., four groups consisting of six bits of information. You will now study a group of six dates or a group of six sets of numbers, rather than all of the dates and numbers.

Breaking down the subject matter into small bits and pieces corresponds to spacing out your study time. You will remember more—and consequently score better on your exam—by studying small bits of information within small periods of time. Grouping information is helpful for your short-term memory.

Have you ever noticed that your attention to and retention of reading material always seems to be better if the book has several small chapters of eight to 12 pages each, rather than four chapters with 50 pages each? In an attempt to practice what is preached, you will note that this book has several chapters consisting of six to 12 pages.

More Review

After you have spaced out your study time and grouped the subject matter into small bits and pieces, you need to continue to "filter this information" into your system through a series of systematic reviews. You have to keep it fresh in your memory for easy recall.

For example, let's assume that you have attended

a three-day concentrated exam preparation course, which is to prepare you for passing a state or federal licensing exam. For three days, you have been exposed to mostly brand-new material. This new information has been "crammed" into your head. The end result is that you can take your exam and, ideally, pass it.

However, following the class, you leave on a three-week vacation. You return from vacation and spend a few hours studying for the exam, and then take the exam and fail it miserably.

You didn't grow "dumb" while on vacation. You grew stale. The information obtained in the three-day exam preparation course started to evaporate, because you failed to continually review it. What should you have done differently?

For starters, you should have spent 10 minutes reviewing the information at the end of the class. Then, later the same day, you should have reviewed the information again. It is frequently a good idea to hold this review just prior to going to sleep. A good night's sleep following a review tends to "cement" the information in your memory.

You should then have proceeded to review some of the material each day, even if only for 20 minutes a day. The goal is to keep the information fresh in your mind.

You must allocate a specific period of time during which you will review small amounts of the information. The important thing is to make these reviews systematically, over a period of time leading up to the day on which you are to take the exam.

If you take the three-week vacation, you must al-

locate appropriate time each day for review purposes. Again, this should involve small doses for short periods of time. When you return from vacation, you should hold a final review with yourself. This will improve your chances of passing the exam.

Continual review is important whenever you have learned something new in a relatively short period of time, especially if you are required to take an exam covering this material.

Play Games

Another technique for improving memory is the use of various visuals and "gimmicks." A *mnemonic* is a device or aid that can help your memory.

Way back in elementary school, you probably learned the expression, "i before e except after c." Committing this slogan (mnemonic) to memory enabled you to correctly spell a large number of words, such as perceive, receive, conceive, receipt, etc. The connection is already in your memory and, consequently, it is easy for you to remember how to spell a particular group of words.

You also may have learned the rhyme, "Thirty days has September, April, June and November." This rhyme serves as an aid to remember the months with 30 days.

Another use of mnemonics occurs with music. "FACE" spells the name of the notes that occur on the spaces of the G, or treble, clef (F, A, C and E). By remembering FACE, you are able to remember and locate the notes.

Creating your own mnemonic aids is easy. For example, let's have a brief lesson on the payment of corporate dividends. When a corporation declares a dividend to be paid to its stockholders, there is a certain time sequence of events. There is a *declaration date* (the date on which the dividend is declared). There is an *ex-dividend date* (the date on which the stock will trade without the dividend). The ex-dividend date is four working days prior to the record date. The *record date* is the date on which all shareholders who own the stock must appear on the corporate records. Lastly, the *payment date* is the date on which the dividend will be paid to all shareholders of record.

If you had to somehow memorize this sequence of events, you might form a visual or mnemonic with the initial letters, DERP. "DERP" is an easy word to remember. The process of paying the dividend starts with D, the declaration date, and ends with P, the payment date. In between these dates are the ex-dividend and record dates. How many letters are in the word DERP? Four letters correspond to the four working days between the ex-dividend and record dates.

Thus, a simple four-letter word can provide you with the ability to recall several bits of information, because the mnemonic establishes a foundation, or connection, for the other bits of information. An illustration of how your memory connects this information follows:

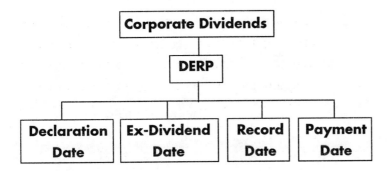

There are various learning experiences where such "mental gimmicks" have served you well. As you continue your lifelong learning, do not hesitate to create your own games to aid in memory and retention.

Use All of Your Senses

If you can see it, hear it, touch it and even smell it, you'll remember it more easily. For example, you are attending a political science lecture. You are listening, watching the instructor, looking at visuals and writing notes. To sit in this lecture and never or seldom look up to catch any of the instructor's gestures or body language limits your sensory perception of this learning situation. After the lecture, you may want to rewrite your notes or verbalize certain key points so that you can "hear it again." The more ways that you can involve your senses, the easier you will find it to remember the material.

Visualizing information also aids memory. We tend to remember pictures, graphics and mental images much more easily than we remember words and numbers. For example, read the following:

A Subchapter S corporation is a corporate business form that pays no corporate taxes as net income is passed through to the shareholder/owners and taxed at the individual's tax bracket.

Depending on your background and prior experiences, this may be easy or difficult for you to remember. However, read the revised version of this same sentence.

A Subchapter S corporation is a bridge between a non-incorporated business and a corporate business form. As such, the Sub S corporation pays no corporate tax, as all net income flows to the shareholder/owners, where it is taxed at the individual's tax bracket.

The wording in this second version enables you to paint some mental pictures. The Subchapter S corporation is a bridge between two entities. You can visualize on one side of the "bridge" a non-incorporated business and, on the other side, a corporation.

The expression, "net income flows ..." sort of completes the picture. You could visualize a couple of people standing on or near the bridge with a "river of income" flowing toward them.

Such mental images can be recalled more easily than words.

Using all of your senses implies that you have to become totally immersed in the learning process. By doing this, you will be able to recall information more easily.

In addition to forming mental pictures, you may want to recite information aloud. By speaking, you

are forcing yourself to listen. You may even want to use a tape recorder and record information for later playback.

Another option is to discuss or debate your study material with another person. By doing so, you are seeing it again and listening to it again.

Relate newly acquired information to past experiences, too. Again, visualize how this new information can be used based on some prior skill or learning activity.

If you consider yourself a visual learner, then you may wish to rewrite your notes or construct an outline from your notes. Back in elementary school, you may have learned spelling and simple arithmetic by means of flash cards. Flash cards were based on new words and problems and were used after you had been exposed to this new material. They served as a review resource and also involved your sense of sight. You saw the word or problem again and again.

Massaging your memory a little or coaxing it a bit by the use of these techniques will facilitate your ability to recall information stored in your brain.

Other Considerations

In addition to the internal techniques just discussed, which were related primarily to learning activities, there are other practical, day-to-day memory aids that are of value to each of us.

Time Control

Time control and management can serve as memory aids. One of the best tools to use is a calendar or a weekly or monthly planner. By using a calendar,

for example, you can plan on remembering something at a future time.

For example, if today is June 1 and you have a dental appointment on July 1, write it down on your calendar or in your daily planner. In fact, you should probably record it twice, just in case you forget to look at the calendar on July 1! Record the day and time of the dental appointment on July 1. Also place an entry on the calendar for June 28 or 29 reminding you that you have a July 1 dental appointment. This way, remembering the appointment is planned for, and you should not forget it.

As part of your daily work or home activities, write down (on a calendar or in a daily planner) what you intend to accomplish on that particular date. Then, first thing in the morning or when you arrive at the office, open up the planner and keep it in view the entire day. As you accomplish a task, check it off.

Checking it off serves two purposes. It makes you look at the planner repeatedly throughout the day, so you won't forget other tasks. It also provides you with a gratification system—in that you visibly see that you are accomplishing your goals.

Manage your time by allocating some planning time at the beginning of the day, so that you will know what has to be accomplished. Then allow some time at the end of the day to review and check on your activities that day.

Notes

Just as effective note taking can enhance listening skills and learning in general, notes also can "jar your memory." For example, as you are leaving your home

for the office, you have to remember to call your doctor for an appointment, stop at the cleaners and make sure that you get gas for the car. Write these things down on a sheet of paper as memory aids.

However, the key thing is to remember to look at your note from time to time. Place it a conspicuous place, such as a pocket you go into frequently, near your phone on your desk or on the seat of your car.

Being Organized

Being a better-organized person can improve your memory and save time. For example, if you can't locate a file in your office, having a better-organized filing system will save you time and you'll remember where things are more easily.

Suppose it is your responsibility to take the day's outgoing mail in your office to the mailbox each day. You have a habit of forgetting to do this, and the mail stays in your office overnight instead of reaching the post office. To break this habit, the mail basket could be moved to a location near the door, so as you leave the office every day, you see the mail. Or maybe the mail basket should be moved into your office or placed near where you hang your coat.

Summary

Memory and learning are closely related concepts. Generally, we learn and process information by means of our brains. Memory is a recall mechanism that enables stored information to be brought to a conscious level.

Newly acquired information goes into our short-term memory. If we review that information, it has a

much better chance of making it into our long-term memory.

Our ability to learn and remember does not disappear (assuming there are no physiological problems). Learning is a lifelong activity, as is remembering. As we grow older, the ability to recall is still there. It may simply be a little slower.

You can keep your memory in "good health" by taking care of it, by coaxing it a bit, by massaging it. Memory aids include:

- **Review and more review**. Review newly learned material immediately, later the same day and periodically thereafter.

- **Pace yourself** by reviewing and studying in short spurts—15 to 20 minutes at a time, followed by brief breaks. Six or seven 15-minute sessions will be more beneficial than one two-hour session.

- **Group information** for ease of retention and recall. Work with short chapters of a book, or divide long chapters into short sections.

- To enhance your memory, **use mnemonics**, draw pictures, use rhymes and similar games. Remembering a picture or a jingle is easier than recalling words and sentences.

- **Use all of your senses** to increase retention and memory. See it, hear it, write it, touch it, even smell it if possible. Involve your total being in the learning activity to enhance your memory.

- **Schedule your activities**. Write them down. Then live by your schedule or plans. You'll find that you forget less and remember more.

- **Time control and management** also will help you be more organized and will serve as a memory aid.

10

Fear of Testing

Your head is beginning to throb. Your breathing is becoming shallow. Your blood pressure has gone up. The palms of your hands are beginning to sweat. You feel a tightness in your chest. And your stomach sounds like a garbage disposal. Are you having a heart attack, a stroke or worse?

The answer to this question is "no." You're simply about to take a test!

Test taking affects people in many different ways. There are those who eagerly await a test because it's a challenge and they have a very competitive spirit. Conversely, there are many who would rather undergo a root canal than take a test. Somewhere between these two extremes is where most of us find ourselves at test time.

Let's "traumatize" you by presenting you with the following short quiz to determine your attitude and feelings regarding testing.

A Test Quiz

Read each statement. If it applies to you, make a T for True in your notebook. If it doesn't apply to you, make an F for False.

1. I usually feel fatigued when taking a test.

2. I am one of the last ones to finish a test.

3. I can't eat before I take a test.

4. I don't score as well on tests as I should.

5. During a test, I often forget the material I studied to prepare for the test.

6. It is difficult for me to stay focused when taking an exam.

7. I'd be perfectly happy if I never had to take another test again.

8. Tests serve no real purpose for anyone.

9. I would rather take an oral test than a written test.

10. I normally feel embarrassed by my test scores.

All of us experience some apprehension when taking an exam, but if you answered "true" seven or more times, you probably have an anxiety attack every time you take a test.

Shame on You!

The trauma you may feel at test time is merely a symptom of another problem. It also helps explain why you may feel physically ill at test time. Generally, the reason is fear—fear of failure. And why do you have this fear? Because part of your early education included a course titled, "Shame on You 101."

As a small child, school was fun. But somewhere around first or second grade (depending on the individual school system), you were introduced to something new—a test. Once we were exposed to tests, learning and education would never be the same.

Initially, taking the test was not the problem: It was the subsequent grade and the system of rewards and punishments associated with your grades. If you didn't do well on a test, your peers may have laughed at or ridiculed you. Occasionally, as your teacher returned your graded test to you, it may have been accompanied by a frown or shaking of the head.

Even the way the teacher wrote your grade on your test paper reflected displeasure. You probably noticed the nice neat "A" on the paper of the girl behind you. Your "D" was large and seemed to be scribbled. Anyone could see the "D" from a distance, because it was so large and it was probably written in red ink. However, the "A" on the other student's test paper may have been smaller and probably in a nice, soft blue.

Your chastisement only increased when you took the test home and showed it to your parents. Perhaps your mother's remark was, "You just wait until your father sees this!" Your father arrived home, physically and mentally tired from a hard day's work, reviewed your test and may have said, "You're grounded!" or worse, "What's the matter with you, are you dumb or something?" Actually, you were and are not a dummy. You proved this by learning what the system taught you—to fear tests.

As you progressed through elementary and secondary schools, your reactions to tests, as well as your peers', teachers' and parents' reactions, only intensified. You may have been grounded so frequently that you began to wonder if you were some kind of mole that would never see the light of day again.

Your feelings at test time may have become very deeply rooted if, along the way, you didn't do well on

an important test, such as a college entrance exam, or if you failed a final exam, causing you to land in summer school.

Your feelings toward test taking were learned with the first sneer by one of your classmates, the first frown by your teacher and your first grounding. You learned about fear and failure because that's what the system taught you—and, unfortunately, Shame on You 101 is still part of the curriculum.

If you're not the dummy they made you out to be because you never did well on tests, then what's the real problem? The real problem is the system and your attitude. Of these two, a positive attitude is the more important. A positive attitude about testing will help eliminate your test phobia and improve your test-taking ability.

How do you develop a positive attitude? The answer is understanding the educational system that taught you your fear of tests—and developing appropriate test-taking skills and techniques.

The System

The system refers to the general educational environment found in our society. It includes teachers and administrators, the curriculum, students, parents and employers.

Teaching is considered both an art and a science. As an art, teaching is creative and represents the skill of motivating and imparting knowledge to students and thus changing behavior. As a science, teaching is based on certain principles of learning, behavior and psychology.

Teaching is one of the more noble professions.

While teachers are frequently ridiculed, often under-paid and not held in very high esteem ("If you can't do anything else, you can always teach"), teachers who practice their art well can mold minds and change behavior.

Changing or modifying behavior (for the better) is the ultimate goal of learning and education. However, the system also can modify your behavior in a negative way—with one example being instilling fear of test taking. Of course, this was not done intentionally. But test apprehension and anxiety are byproducts of the educational system's attempt to measure learning and success.

The rationale is that we must have some indicator, some method of measuring the level of learning that has taken place. This is most commonly a measurement test. If that test grade is accompanied by the teacher's frown, other students' ridicule or parental punishment, then taking a test even 30 years later as an adult may still result in sweaty palms, increased blood pressure and a general state of anxiety.

A secondary question becomes: Are we attempting to measure the student's progress by testing, or are we measuring the teacher's lesson plans and ability to teach? The teacher needs some reassurance that the subject matter is being presented in such a manner that the students are learning, as evidenced by the grades received on tests. If the grades are good, the teacher must be doing a good job. If the grades are very low, then perhaps the lesson plans need to be changed.

Are there alternatives to testing as a measurement

of learning? Naturally. Simple observation is an appropriate alternative. If the student couldn't do multiplication at the start of the semester but had the ability to multiply by the end of the semester, then learning has taken place. Why the ordeal of a test? If the student couldn't write a simple paragraph last month, but can this month, something has been learned. Why the need to test?

Student introspection (self-assessment) is another method for measuring learning. The teacher simply asks the student what he or she has learned. Most elementary school children are very honest. They will tell you what they learned or what they didn't learn. They will state that they did the best they could, or that possibly they could have done better. So why the need for testing?

One answer to this question is that the entire educational system or environment is built on tests and grades. If the elementary school teacher simply observed students and wrote individual evaluations (similar to kindergarten and early elementary grades), then what would happen when the child reached high school? The high school principal or counselor would want to know what? The student's grades! One of the criteria for admission to college is adequate grades. Eventually, a prospective employer may even ask to see a transcript of courses and grades.

Idealistically, we probably could measure learning adequately without the trauma of test taking. Practically, it may be impossible because of the expectations of the overall system—the parents, high school administrators, colleges and employers.

Certainly, tests could be administered, especially in the early elementary grades, without the stigma of the letter grade. Administer a particular test, indicate where mistakes were made, but don't place a grade on the test. If the teacher needs a grade, place it in the student record or class book. The test then becomes a measurement and an evaluation for the student, whereby he or she knows where mistakes were made and which areas need improvement. In other words, the test becomes a guide for the continued progress of the student.

Thus, the potential trauma created by tests and grades can be lessened by how and when an individual is introduced to them. The older the student is, the more likely he or she is to have the ability to deal with the negative aspects of tests and grades. Unfortunately, when fear of tests is ingrained in a young child, it may well stay with him or her forever.

As an adult learner, you may have difficulty taking tests. The first step toward improving the situation is to understand why you have this difficulty. It is not that you are a "dummy." You are simply a product of the system. If you have a fear of tests, the system taught you this at an early age. Knowing this now leads you to the next step, and that is to try and approach all learning and testing situations with a positive attitude.

Your attitude toward tests can predispose you to success or failure.

Attitude

> **If you think that you will fail, you will fail.**
> **If you think that you will pass, you will pass.**

Often, your attitude serves as a self-fulfilling prophecy. If you believe that you won't pass a test, chances are you won't. And then you say to yourself, "I knew I wouldn't pass it."

You are not an innately inferior test taker. The system taught you how to be apprehensive about tests, which in turn has led you to the belief that you're no good at taking tests. There's not much you can do about the system, but you certainly can rid yourself of your negative attitude.

The following story demonstrates the impact of attitude on test taking and results. This is a true account of a very large insurance company and its attempt to have potential new agents pass licensing exams in the state of New Jersey.

Throughout the state of New Jersey, the company was hiring approximately 25 to 30 new agents per month. A condition of employment was that the individual had to have a Life and Health (L&H) insurance agent license, a Property and Casualty (P&C) license and a securities license—the National Association of Securities Dealers (NASD) Series 6 license.

These new hires were to attend a three-day exam preparation course for the NASD Series 6 exam. The state of New Jersey required that they complete a one-week course prior to taking the L&H exam and a three-week course prior to sitting for the P&C exam.

Managers were sending these new hires to the three-day Series 6 class with the following message: "Go to the class. You won't pass the test the first time, but it's okay. You'll have to wait 30 days to sit for the exam a second time and, during that month, you can complete your one-week L&H class and your three-week P&C class. Then you can retake the Series 6 exam, and you'll do better the second time."

The insurance company's senior management was perplexed by the fact that only 44 percent of the new hires were passing the NASD Series 6 exam on the first try. An analysis of the situation revealed the negative attitude being implanted in the new hire's minds: "You won't pass the test the first time ..."

Basically, the managers were given a cease and desist order: Cease and desist from sending new hires to the Series 6 class with the negative message.

Over a period of approximately six months, as the negative attitudes were slowly changed, the pass rate increased to about 70 percent. The class hadn't changed. The material hadn't changed. The instructors hadn't changed. The new hires were not any smarter. The only thing that changed was the attitude. No longer were these individuals predisposed to failure.

A positive attitude can overcome many obstacles to learning, as well as test taking. If you believe in yourself, prepare for the exam and say to yourself that

you will pass this test, chances are excellent that you will indeed pass the exam. But if you approach an exam (as the new agents did in New Jersey) with anxieties and a belief that you won't pass, you probably will fail.

Let's Make It Better

As adult learners, our beliefs and attitudes have been shaped over a long period of time. We have developed certain self-perceptions. It is not easy to change these attitudes. But, as Scrooge found out in Dickens' *A Christmas Carol*, it's not too late to change the future. There are certain steps you can take to modify your attitudes about learning and test taking.

The Steps to a Positive Learning Attitude

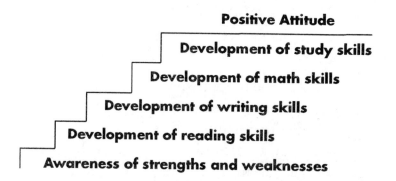

Positive Attitude
Development of study skills
Development of math skills
Development of writing skills
Development of reading skills
Awareness of strengths and weaknesses

Basically, these steps most logically begin with Chapter 1 of this book. This section on attitude is near the end of the book by design. If you put into practice the techniques and ideas presented in the earlier chapters, you will be moving in the right direction to change your attitude.

First of all, you must recognize your own strengths and weaknesses. Lead with your strengths and work to improve your weaknesses and you can improve your self-perceptions and attitudes. By renewing your enthusiasm for learning and awareness of various learning skills, your attitude will be enthusiastic—it will be positive.

**Effective Learning =
Enthusiasm + Attitude + Skills**

Improving reading, listening, writing and math skills will make you feel good about yourself. Improvement in these skills should contribute to more learning successes and, if tests are involved, you should perform better. If you now have a better understanding of potential test material because you write better notes or are a better listener, you should consequently do better on exams. You can slowly divorce yourself from those negative images that were planted in your mind by the system.

Summary

Improving your ability to deal with tests begins with an evaluation of your strengths and weaknesses regarding test taking. If you are a poor test taker due to the apprehensions and anxieties associated with test taking, these problems can be resolved by understanding why the problem is there and developing a positive attitude.

Frequently, apprehensive test takers are products of the educational environment, meaning the schools, teachers, parents and employers of our society. Once

upon a time, school and learning were fun. Unfortunately, some of us were taught to fear tests.

The key to any success in life—including test taking—is a positive attitude. A positive attitude and knowledge of appropriate test-taking techniques will enhance your ability to be a successful test taker.

11

Test-Taking Techniques: Essay Tests

Once you understand the reasons why you may not be a "good test taker" (the system and your attitude), your next step in improving the situation is to sharpen your test-taking skills. You now need to focus on the mechanics of test taking.

The Mechanics of Test Taking

**Test-Taking Success =
Attitude + Content + Test-Taking Skills**

We have already discussed the importance of attitude, as well as various study skills for retaining content. This chapter and the following two chapters will focus on test-taking techniques and skills for various types of tests.

There are those who have very superficial knowledge of the subject matter but generally do reasonably well on tests. Then, there are many people who master all the content and still can't pass the test.

Generally, poor test takers make too many careless or mechanical mistakes. Good test takers limit their "dumb mistakes."

A careless or mechanical mistake is selecting choice C as your answer to a test question, when you actually meant to pick choice B. Or you answered a question incorrectly because you failed to see a small word, such as "not." Possibly a question may have read, "Which of the following is not true regarding the Declaration of Independence?" You answered this incorrectly because you misread the question.

There are two broad categories of test questions—essay and objective questions. Most tests are objective, but occasionally you may be faced with an essay test. An objective question is usually very specific. In contrast, an essay question generally covers a wider area.

Many people feel much more comfortable with objective tests, which include multiple choice, matching questions and true and false questions. Yet there are those who feel more at home with essay questions. Essay questions allow you to "talk" more freely by answering a question by means of several paragraphs. This chapter will address the essay question (also known as a "recall-type" question, since the answer must be recalled from the memory of the test taker).

Move Over, Beethoven

Working with essay questions is like composing a song. Most popular songs consist of a main theme. This theme is usually presented at the start of the song and repeats itself at the end of the piece. In between, there are a few measures of music that more or less complement the principal theme. The result is a musical composition.

Let's use "Jingle Bells" as an example:

"Jingle bells, jingle bells, jingle all the way."

The music that goes with these words is the main theme. Following this theme are some additional words and music ("Oh what fun it is to ride ..."), and then the main theme repeats itself.

Answering essay questions is a bit like singing "Jingle Bells." You will have a main theme (a topic sentence), followed by other sentences that support the main theme, ending with a conclusion of some type, which probably repeats the main theme.

Let's assume that you have been asked the following essay question:

> What do you feel was the primary cause for the Civil War? Explain your answer.

Your response might be similar to the following:

> The principal reason for the Civil War was economic. (**topic sentence**) The South felt economically threatened by the abolitionist movement. The end of slavery would have a tremendous impact on the economy of the rural South, which was dependent on slave labor. The plantation system was profitable, as long as the cost of labor was cheap. Providing some food and shelter for slaves resulted in inexpensive labor. Although he didn't run for election as an abolitionist, the election of Abraham Lincoln was the final threat to the South, as he was generally viewed as being in favor of abolishing slavery and, consequently, destroying the economy and culture of the South.

The sentences that follow the topic sentence support the main theme—the economic causes of the Civil

War. The last sentence sums up the main theme.

Preparation

Needless to say, part of your preparation for an essay exam requires that you have a broad knowledge of the subject matter. If you know the dates of the Civil War and some of the principal battles that were fought, these facts will be of little value when you are asked for the principal "cause" of the Civil War. (Conceivably, these same facts may be of some value if you're facing a multiple choice exam on the Civil War.)

So, the first step in preparing for the essay exam is to have a broad knowledge of the subject matter. Next, you can prepare for your essay exam by writing some practice essay questions. Here, you are "second guessing" the instructor. You review your notes and/or reading assignments and compose some sample essay questions that you feel the teacher may ask. Naturally, as part of your test preparation, you'll need to answer the essay questions you have composed. You can then use these questions and answers as key review tools.

As you prepare for an essay exam, it is important to think about and understand concepts. In our example, the concept is the economic cause of the Civil War, as opposed to specific recall of dates or events. Think of the economic causes as being an umbrella, under which are such items as slavery, inexpensive labor, the abolitionist movement, the economics of the plantation system and the election of Abraham Lincoln. Thus, the mental picture of the umbrella becomes the essence of your essay answer.

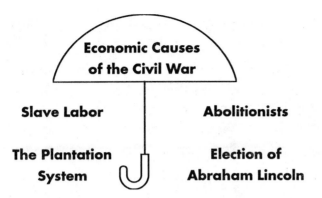

Economic Causes
of the Civil War

Slave Labor

Abolitionists

The Plantation
System

Election of
Abraham Lincoln

In summary, essay test preparation starts with a comprehensive knowledge of the subject matter, with an emphasis on understanding key concepts or ideas. Write and answer some essay questions of your own covering the material you will be tested on. Remember, each paragraph should start with a topic sentence or main idea, followed by supporting information and a conclusion.

The moment has arrived for the actual essay exam. The first thing you should do is read *all* of the questions to get a feel for what is generally being asked of you.

One of the real dangers of an essay test is that you may know a lot about one or two of the questions and less about other questions. The tendency is to write, write, write about that with which you are most familiar, which results in using much of the allotted test time. Then you look at the clock and you've just about run out of time for the remainder of the test.

Test Time!

By reading all of the questions first and allocating time accordingly, you also will get a feel for how extensive or brief your essay replies need to be. If you are to answer four essay questions in an hour, you could probably write one or two pages for each question. But a 10-question one-hour essay exam should tell you to be brief, possibly writing only one or two paragraphs per question.

You also should budget your time according to the number of questions being asked. For example, if a one-hour essay test asks four questions, then you should allocate about 15 minutes per question. On the other hand, if a one-hour essay exam asks 10 questions, each question is worth about five to six minutes of your time.

Avoid
Mechanical
Errors

If you have prepared properly, don't blow it now by making careless mistakes. Avoiding the "dumb mistakes" begins with reading the entire question. Misreading the question or not understanding some words can be fatal to your final score.

At the top of your paper print the letters, "RTFQ." This is an important reminder to you to Read the Full Question. Make sure you see and understand every word in the question. Read it once. Read it twice. Make sure you understand what the question is asking before you even think about answering it. For example, if the question is asking you to explain the difference between an apple and a banana and you proceed to write about fruit salad, you didn't understand the question and made a careless mistake.

There are certain key words that commonly appear in essay questions. You should make sure that you understand the intent of these words or phrases.

Compare and contrast. The first key word, compare, means to indicate the *similarities* between two concepts or things. For example, "compare a passenger car to a pickup truck" means how is a passenger car like a pickup truck? You might write that both are types of transportation. Both require gasoline. Both are operated on public roads ...

When asked to contrast two concepts, you should write how two items are *dissimilar*. For example, a car is more comfortable than a truck. A car is more economical than a truck. A car carries more passengers than a truck. A car carries less cargo than a truck ...

List or classify. These terms usually require that you identify, list or enumerate points or items. For example, "Identify the principal elements of a legal, binding contract," would probably cause you to enumerate several items, usually in some type of numerical order.

Generally, this type of essay question simply asks for recall of specific items. It's as if you're making a shopping list. No explanations or descriptions are necessary—just provide the required list of items.

Describe or discuss. These words tell you

that you are to provide specific or detailed information about the topic. For example, "Discuss the impact of third-party candidates on presidential elections." Here, your job is not to list items or compare or contrast, but rather to describe and discuss in detail the effects of third-party candidates on the presidential electoral process.

This type of question could require you to write several paragraphs or pages on the subject. For example, you might write a paragraph on the effects of third-party candidates on the Democrats, the Republicans, the Electoral College, the polls, the general public, voters in large industrial areas and voters in rural areas.

Give reasons for your answers. This phrase requires that you justify your responses and explain in detail the reasons for your answers. It is not enough to simply answer the question by writing a sentence or two.

For example, a question might read, "What was the primary reason for the start of World War I? Give reasons for your answer." This question requires that you write a central fact—the assassination of Archduke Ferdinand. Then, you must explain why this assassination started the war—i.e., nationalism and treaties between various European countries. Providing only the main answer

without the supporting details usually results in a lower score on the question.

Evaluate or analyze. This type of question normally requires that you make a "judgment call." When asked to evaluate or analyze a situation or an issue, you're being asked for your opinion regarding a matter. However, it is your opinion based on factual information. In other words, you simply can't "make up" an answer.

For example, "Evaluate negative childhood testing experiences on present attitudes toward testing."

Theoretically, you could argue the point that early childhood experiences have no effect on current testing attitudes, or you could argue just the opposite. It's as if there is no correct answer, since you can provide an opinion for either side of an issue. However, you do have to provide supporting evidence for your position.

A Brief Outline

In addition to making sure you have read and understood the full question before you actually begin writing, you may wish to briefly outline the content of your essay response. Identify your main topic or idea, jot down supporting data and your conclusion.

This is not to be an extensive outline. If you're going to write one long paragraph, this brief outline shouldn't take more than a minute or two. If your

response is a page or two long, then your outline may take you a few minutes.

This brief outline allows you to organize the information you intend to use in your answer. It also helps you to remember certain points so that you don't omit them as you write out your response.

Using Connectors

You should also strive to make your essay response cohesive. Your response may require several paragraphs. Naturally, each paragraph will contain a topic sentence or main theme with adequate detail and support. To assure that all of these paragraphs are well organized and coherent, you should use certain "connectors."

Connectors are words or phrases that serve as bridges between paragraphs or between ideas within a paragraph. The use of these words serves to provide clarity and cohesiveness.

Examples include the following:

Finally	Initially	Secondly
Thus	Subsequently	Also
Therefore	Nevertheless	Thirdly
As a result	To begin with	Related to
In conclusion	On the other hand	First of all
In addition	In summary	Consequently

Bridges for Clarity

A word of caution—don't clutter your paragraphs with excessive use of these connecting words. Use them where appropriate to clarify and connect related ideas.

When completing an essay test, you can get into trouble if you don't write enough or if you write too much. Frequently, either of these situations is an indication that you don't know the material very well.

If you are answering four questions on a one-hour essay exam and you're finished after 20 minutes, you are in big trouble. Either you're the world's fastest writer, or you have a problem with content. You simply don't know enough about the material to write for nearly an hour. When this situation occurs, there is a tendency to go back and add extraneous material to what you've already written to fill up the time and fill space.

Don't Filibuster!

Your written filibustering will not go unnoticed. If you have established a main point or topic sentence for each of several paragraphs and lack adequate detail or explanation, rambling on with irrelevant material in order to fill up the space will only compound your problem.

The development of short content outlines before you begin writing will help prevent a written filibuster. You will establish your main point and then stick to it by means of supporting details, such as examples and facts. If you can't fill in with relevant details and explanations, rambling on serves no purpose.

Basically, you either know it or you don't know it. Filibustering only emphasizes your lack of knowledge.

Summary

Successful test takers have a positive attitude, knowledge of test content material and good test-taking skills.

When writing an essay test, it is important to construct good paragraphs. A paragraph should begin with a topic sentence and then follow with supporting sentences.

Avoid careless mistakes and mechanical errors caused by not reading questions carefully. Read the question twice for understanding. You should be able to correctly identify what the question is asking—e.g., analysis of information or compare and contrast. An accurate understanding of what the question is asking is critical to answering essay questions successfully.

Essay tests require that you spread out your test time according to the number of questions asked. This

enables you to write adequate amounts of information on all questions, instead of a lot of information on only a couple of questions.

You should attack an essay test by writing a very brief outline of what you intend to write. This will keep you on track and will help you avoid omitting important information. Link paragraphs with connecting words or phrases to maintain continuity and clarity in your answer. And don't filibuster.

CHAPTER 12
Test-Taking Techniques: Simple Objective Tests

The worst is over. The dreaded essay test is behind you. From here on, all of the tests you take will include the answers! You simply have to be able to identify or recognize those answers. (These are also known as recognition-type test questions.)

In contrast to essay questions—where test answers must come from within you, the test taker—objective tests reduce or eliminate subjective factors in answering questions by providing you with a true-false test, a matching test or a multiple choice exam.

Answers
Included

**Test Taking Success =
Attitude + Content + Test-Taking Skills**

As you can see, nothing much has changed since the previous chapter. If you are going to be a successful test taker, you must maintain a positive attitude about testing, have some mastery of the test content and use sound test-taking skills. The only thing that has changed is the type of test to be taken.

We have already discussed attitude in other chap-

ters of this book. And it is understood that if you are to do well on any test, essay or objective, you must use your note-taking skills, listening skills and study skills to have adequate knowledge of the test content.

As always, you must prepare for any test. Often, there is a tendency to put in more preparation time with essay-type tests because you must come up with the answers from "scratch." In some minds, multiple choice tests are "easy" because the answer is there—somewhere. Nevertheless, to avoid turning a multiple choice exam into a multiple guess exam, proper preparation is required. You must study and review the test material.

This chapter will be devoted to various test-taking skills or techniques relative to objective-type tests.

General Test-Taking Techniques

As is true with any test, it is important to **understand concepts**. If you understand the basic thought, premise or idea, then you should be able to answer any type of question. For example, as air is heated, the molecules begin to move and expand and, consequently, warm air rises and colder air sinks. Conceptually, you understand this principle.

If you are asked a true or false question regarding the effects of heat on air or a multiple choice question covering the same concept, you should be able to answer the question because you understand the underlying concept—the big picture. However, if you only memorized the fact that warm air rises and you really don't understand why, you may have difficulty answering any question that deals with the reason that air as a gas expands, becomes lighter and rises.

To oversimplify the point, let's assume that you only memorized "two plus two equals four." You have mastered this problem as you prepare for a test. However, instead of asking you how much "two plus two" equals, the test question states, how much is "three plus one"? Because you don't understand the concept of "what makes a four," you may have difficulty answering this question.

Objective tests typically ask specific questions. Therefore, it may be necessary to **memorize** certain facts, figures, names, places and dates.

Understanding Concepts + Memorization = Objective Test Success

Start With the Easy QuestionsAnother general test-taking technique is to **scan** the entire test. Get a feel for what's being asked or how difficult the questions seem to be before you begin to answer questions. Then answer all of the questions that you feel positive about.

Let's assume that you are taking a 100-question multiple choice exam. You need to score 70 percent to pass this exam. After briefly reviewing the entire exam, you start to answer those questions for which there is no hesitation—no doubt in your mind that you're selecting the correct response. Possibly, you may answer 50 questions in this manner. The remaining 50 will take some thought.

To improve your attitude or provide yourself with a boost of confidence, you could now say to yourself

that of the remaining 50, you only need to get about 20 of them correct. This assumes that you didn't make any careless mistakes on the 50 answers you were sure about. You then conclude that anyone ought to be able to answer 20 questions correctly out of 50, and you feel much more confident as you go back over this test to answer the remaining questions.

Blow Away the Smoke

Again, be sure that you read the entire question very carefully. You may want to **underline key words** in the question so that you do not miss what the question is asking. Of course, frequently, tests are given on computers these days, and underlining key words in a question may not be possible. Still, you can certainly identify the key words, even though you can't underline them.

For example, what do you feel is important in the following question?

> Five years ago, Charlie purchased 100 shares of the ABC Mutual Fund at a price of $10 per share. Charlie felt that he could double his investment over five years. Due to a medical emergency, he is now being forced to redeem these 100 shares. The current purchase price is $11.50 per share and the current redemption price is $11 per share. How much will Charlie lose or gain if he redeems the 100 shares today?

Ideally, you read this question carefully and possibly even read it twice. There is some extraneous infor-

mation contained in the question—information that is not important with regard to determining the answer. You need to "blow away the smoke" to get to what is important. You can accomplish this by underlining the important parts of the question. Repeating the question with underlined parts:

Five years ago, Charlie <u>purchased 100 shares</u> of the ABC Mutual fund at a <u>price of $10 per share</u>. Charlie felt that he could double his investment over five years. Due to a medical emergency, he is now being forced to <u>redeem</u> these <u>100 shares</u>. The current purchase price is $11.50 per share and the <u>current redemption price is $11 per share</u>. <u>How much will Charlie lose or gain</u> if he redeems the 100 shares today?

Once the smoke is blown away, we are dealing with the purchase of 100 shares at $10 per share, redemption of those shares at $11 per share, and how much of a gain or loss has occurred. The remaining information is just smoke—information that is not relevant to the question being asked, which is: How much of a loss or gain is being realized?

Understand the Question

It cannot be stressed enough that before you attempt to answer a question, you must first understand the question. This understanding is achieved by carefully reading each word in the question. Let's look at the following sample test question:

> All of the following are true regarding the functions of the United Nations, except:

If you read this question and didn't see the word *except* at the end, you would be looking for statements that are true regarding the United Nations. The question is asking you to identify something that is not true.

It would be easy to miss the word *except* if you're not careful. It's the last word in the statement. Your mind wants to "take a peek" at the responses and, before you reach the end of the question, your eyes begin to drift toward the possible answers. Don't jump the gun. Read the question carefully and underline the word *except*.

If we change the United Nations question slightly to read:

> Which of the following is not a function of the United Nations?

Here again, if you're not careful, you may miss the word *not* in the question, especially if you're running short of time to complete the test and you're reading very quickly. If you slow down a bit and read the question carefully, you would probably underline the word *not*. In addition, you also should underline or focus on the words *function* and *United Nations*.

You have to crawl before you walk. You have to

crawl through the question before you walk through the responses to select your answer.

A final test-taking technique that everyone has heard from time to time is, generally, your first choice for an answer should not be changed. This is especially true if you were forced to take a guess at an answer. Usually, your first guess will be your best guess. Don't second guess yourself by changing a possible correct answer into an incorrect response.

Stick by Your
First Instinct

In the real world today, you seldom are faced with a true-false test. In theory, you could answer all of the questions true (or all false) and score about 50 percent. If we assume that tests are designed to measure learning and knowledge, a 50 percent score on a true or false test would seem to measure that you're "lucky" about 50 percent of the time.

True or False
Tests

However, if you are properly prepared for a true-false test, you should do better than 50 percent. Generally, you should approach this test in much the same way you would approach any objective test. Preparation means:

- Proper study of the test material

- Maintaining a positive attitude

- Understanding key concepts

- Some memorization of pertinent facts

Naturally, as you begin to take the test, you should scan the entire exam, and get a feel for the complexity of the exam and the time that it may take you to com-

plete it. You could then approach the exam by carefully reading each question, underlining key words and first answering all those questions that appear to be the easiest. Then go back over the exam and answer those questions that require a little more thought.

Clue Words

Generally, there will be some questions that may require you to take an educated guess—when you're simply not sure of the answer. Fortunately, you've got a 50-50 chance of guessing correctly. However, you can improve these odds by paying attention to certain clue words, which may appear in the question.

Questions that contain the words "all," "always" or "never" are usually *false* responses. These words usually imply a universal—no exceptions—type of statement. There are exceptions to almost everything. For example, read the following statements:

- All men are honest.

- Liquids always freeze at 32 degrees Fahrenheit.

- The IRS never makes mistakes when auditing taxpayers.

At first glance, you may want to answer these statements "true." However, all men are not honest. We could say that most are honest, but not all. Alcohol is a liquid that does not freeze at 32 degrees. Out of fear and apprehension, we may think that we make tax mistakes, but the IRS doesn't. The IRS does make mistakes, however.

Thus, when you are forced to guess on a true-false test, take a second look and determine if any of these clue words are in the statement. If so, statistically, the odds are in your favor if you guess false.

There are also certain clue words that generally result in the correct response being *true*. Examples of such words would be "generally," "usually," "frequently," "most" and "probably." Read the following statements:

- Generally, most men are honest.

- Frequently, liquids freeze at 32 degrees Fahrenheit.

- Usually, the IRS does not make many mistakes when auditing taxpayers.

Guessing true to statements that contain these clue words probably will improve your chances of guessing correctly.

The use of these clue words removes the statement from the position of being universal or without exception. These words hedge the question or qualify the statement, and thus should lead you to guess *true*.

Matching Tests

Matching tests also are seldom used in adult learning situations. Nevertheless, we will spend a few moments discussing some of the techniques of taking matching tests.

Again, proper preparation and attitude are key ingredients for success with matching tests. If you know the material being tested, you should do well. However, there are certain testing techniques common to matching tests that you should be aware of.

As usual, scan the entire test to determine complexity and timing. Read the statements and underline key words. As you begin to actually answer questions, work with the column that has the longer statements and match these entries to the shorter statements in the other column.

Following is a sample matching test covering government health-care benefits.

Sample Matching Test

Column A	Column B
1. Health-care benefits for the financially needy.	A. $736
2. Hospital insurance under Medicare.	B. A Medicare supplement
3. Health-care benefits for the aged and the disabled.	C. Medicaid
4. This part of Medicare covers doctor's charges and out-patient expenses.	D. 90 days
5. This product is designed to fill the gaps left by Medicare.	E. Hospice care
6. A voluntary program that provides pain control and treatment for the care of the terminally ill.	F. $100
	G. Part A
	H. Skilled nursing care
	I. 60 days
	J. Part B
	K. Social Security
	L. Medicare

7. Twenty-four hour a day care provided in a nursing home under the supervision of a medical doctor.
8. A benefit period under Part A of Medicare.
9. The number of lifetime reserve days under Part A of Medicare.
10. The Medicare Part B deductible.

After you scan this test, you would probably note that Column A has 10 statements, while there are 12 responses in Column B. Therefore, you will not use all of the responses in Column B.

You should read the statements in Column A (the longer statements), then attempt to match the statement to the response in Column B.

Again, answer those questions that you are sure of, leaving the more difficult questions or your guesses to the remainder of the choices.

As you pick your answers from Column B, check off the responses you select, so that as you complete the remainder of the test, you also reduce the number of choices.

Let's assume that you have answered 7 of the 10 questions as follows:

Sample Test in Progress

Column A

C 1. Health-care benefits for the financially needy.

G 2. Hospital insurance under Medicare.

L 3. Health-care benefits for the aged and the disabled.

J 4. This part of Medicare covers doctor's charges and out-patient expenses.

B 5. This product is designed to fill the gaps left by Medicare.

E 6. A voluntary program that provides pain control and treatment for the care of the terminally ill.

H 7. Twenty-four hour a day care provided in a nursing home under the supervision of a medical doctor.

___ 8. A benefit period under Part A of Medicare.

___ 9. The number of lifetime reserve days under Part A of Medicare.

___ 10. The Medicare Part B deductible.

Column B

A. $736

✔ B. A Medicare supplement

✔ C. Medicaid

D. 90 days

✔ E. Hospice care

F. $100

✔ G. Part A

✔ H. Skilled nursing care

I. 60 days

✔ J. Part B

K. Social Security

✔ L. Medicare

You appear to have been able to recall everything except "numbers." Column B choices A, D, F, I and K are available for your last three answers.

Guessing has its place when taking an objective test—and this is it. You can improve the probability of guessing correctly by carefully reading questions, identifying what type of answer you should be looking for and picking from remaining choices after having used or eliminated most of the other responses.

For instance, questions 8 and 9 require a period of time expressed in days. Therefore your choices become D (90 days) or I (60 days). Since you have checked off or eliminated all the other possible answers, perhaps you may be able to recall the correct answers to these two questions. If not, take a guess! If you are forced to guess, at least you have a 50-50 chance. You can now make a good, educated guess.

It would appear that question 10, "The Part B deductible," has to be answered with dollars and cents. Therefore, choices A and F become your possible answers. Then you may say to yourself:

The deductible on my car insurance is $200. The deductible on my hospitalization plan is $500. My choices are $100 or this odd amount of $736. I'll take a guess at $100, choice F.

Choice F is the correct answer. Let's hope you can recognize this by systematically eliminating most of your possible choices, and then recalling other similar learning experiences. This way, you are able to make a very good guess at the correct answer.

(By the way, if you're wondering about the answers to questions 8 and 9 on the matching test, the correct answer to No. 8 is D, and No. 9 is I.)

Summary Whether you are preparing for a subjective test or an objective exam, your success will be directly related to your attitude, test preparation and your test-taking skills.

Objective tests typically require that you understand the big picture—key concepts—and you may have to memorize certain facts or figures. Remember, the objective test gives you the answer, but you still have to be able to recognize it.

As a general rule, you should scan the entire test. This will give you a feel for the complexity of the exam and the potential time that it may take you to answer the questions. You should then proceed to answer all of the "easy questions"—those questions that you feel positive about.

After having answered the questions you are sure of, you now need to review those questions that will require more of your time and thought before you can arrive at the correct answer.

It is critical that you read the full question and understand what the question is asking you. You need to have an accurate understanding of the question to locate the proper answer.

When working with the more difficult questions or being forced into a guessing situation on true or false tests, look for certain clue words, such as "always," "never," "generally" or "usually," which will help you make an educated guess.

The approach to a matching test is similar to that of any other objective exam—scan the test, and answer those questions that you are sure of first. In addition, you should always work with the column that has the

longer statements or sentences, and attempt to match them to the column with the shorter statements. Check off each response as it is selected.

13

Test-Taking Techniques: The Multiple Choice Test

While true or false tests and matching tests are generally not given in the real world to the adult learner, the test-taking skills and techniques mentioned still have value.

As an adult, you may take a test as a condition of potential employment, to measure a job-related skill, to obtain a license or simply as part of your continuing education through college work or vocational study. Your adult testing experiences generally will be more difficult than the true/false test and will likely include a series of multiple choice questions.

As an adult learner, you may not have taken a meaningful test in several years. You may be a bit rusty. You certainly will have to sharpen your test-taking skills pertaining to the multiple choice tests you will be exposed to as an adult.

Granted, you still need to prepare yourself and know the subject matter, but the ability to manage and work with test questions is also very important. A superficial knowledge of the subject matter coupled with excellent test-taking skills will often result in a passing test score.

Anatomy of a Question

The typical multiple choice test question (also referred to as a multiple guess by the unprepared) consists of an objective question with four alternative responses from which the correct answer(s) will be selected. Generally, these test questions are commonly referred to as *items*, and the item may be in the form of a question or a statement.

A test item consists of a *stem* and *options*. The *stem* is the question or statement. Usually only one of the *options* is the correct response. This correct option is normally identified as the *key*. The incorrect options are aptly identified as *distracters*.

A Sample Item

The Stem [Washington, D.C., is the capital of:

Options
- A. China.
- B. England. **Distracters**
- C. Japan.
- D. The United States.] **The Key**

Success is achieved when you avoid becoming distracted by the distracters and find the key.

Know What You're Working With

Before you bake a cake, you identify and measure all of the ingredients you will use to make the cake. Before you prepare for a round of golf, you make sure you have clubs, tees, balls and a towel. You also think about certain holes, greens and fairways on the course before you actually play the round. Before you as-

semble a child's toy, you lay out the 101 easy-to-assemble pieces so that you can see what you're working with before you begin this nightmare. You prepare for these activities.

You also must prepare for an objective exam by reviewing and studying the appropriate material, scanning the test before you begin to answer it, dealing with those questions you feel most comfortable with first and underlining key words and phrases. In addition, you need to know the type of questions you are likely to see on the test.

Generally, there are four types of multiple choice test items.

The Definition Question

The definition question is usually a short, simple test item that asks you to define a point or concept. For example:

Astronomy is:

A. The study of the sun.
B. The science of the universe.
C. A method of studying the earth.
D. The art of using telescopes.

This item is very short and direct, and each option is also relatively short and straightforward. This type of test item usually makes us feel good because it is short and it looks pretty simple. We tend to relax a little more when we see the definition-type question.

A definition question also can provide you with

the definition, then ask you to identify what term is being defined.

"The science of the universe in which the origins, evolution, composition, motion and location of the stars and planets are studied" best defines:

A. Astrology.
B. Astrophysics.
C. Astronomy.
D. Cosmicology.

Although the stem is a bit longer, the options are nice and short and, again, we frequently view this type of question as "easy." Typically, this is the type of question that you will answer the first time through the test.

The "Except" Question

The "except" question may require that you temporarily become reprogrammed. For most of the test, you have been searching for true responses. Suddenly, the following question appears:

All of the following are true of our federal government except:

A. The president is appointed to a four-year term.
B. The Supreme Court is part of the judicial branch of government.

> C. The House of Representatives is a legisla-
> tive body.
> D. Each state elects two senators.

This question requires that you find an answer that is incorrect—untrue or false. You should step back, take a breath and say to yourself that the false answer is the correct response. You don't want to find a correct answer. You must locate an incorrect response.

Careful reading of the test item will tell you what to do—"All of the following are true except ..." Find the exception. Find that which is not true.

A variation of this type of objective test item is as follows:

> Which of the following is not true regarding our federal government?
>
> A. The president is appointed to a four-year term.
> B. The Supreme Court is part of the judicial branch of government.
> C. The House of Representatives is a legislative body.
> D. Each state elects two senators.

This question is actually asking you for the same information. The important thing is to make sure that you read the question carefully and see the word *not*. If you miss this word, it changes the whole meaning of the question.

The Story Question

Way back in elementary school, you were exposed to the story problem for the first time. It went something like this:

> Mary has $1. She has been instructed to go to the store and buy pencils. If each pencil costs 10 cents, how many pencils can Mary buy?

This question was asking you a division problem in the form of a short story. You could have been asked, "How much is $1 divided by 10?" But it was time to complicate your life a bit, so the division problem was hidden in the story. You had to be able to identify the mathematical process in the story in order to answer the question.

Story problems are used abundantly in multiple choice exams. Frequently, individuals become confused and frustrated with story problems. Usually, they are long, take up a lot of space and contain considerable information, most of which is not pertinent to the point being tested.

The challenge becomes picking the important information out of the question and discarding the irrelevant. Normally, you will have to read this test item more than once to determine what is really being asked of you. It is also advisable to underline the important information needed to arrive at the answer.

Read the following story questions and determine what the actual test item, or question, is. Write that question in your notebook.

Bill has been attempting to sell Paul some life insurance. He has tried every closing technique he knows, but Paul is reluctant to sign the application and buy the insurance. Finally, Bill offers Paul one-half of the commission if Paul will sign the application at once. This offer is an example of what?

Question 1

Karen works for Acme Inc. and is not a participant in the company pension plan. Karen maintains an Individual Retirement Account (IRA) and has made the maximum $2,000 annual contribution permitted by law to the account for many years. This year, she made a contribution of $2,500. This is an excess contribution subject to a penalty by the IRS. How much will she be penalized?

Question 2

An investor purchased a bond from the Acme Corp. many years ago. The bond has paid 10 percent interest for the past 20 years, but will mature in two weeks. The investor has decided to reinvest in another Acme bond at maturity. However, the interest rate to be paid on the new bond is only 6 percent. Since interest rates have fallen, the price of the new bond will be _____.

Question 3

Question 4

> Jack is concerned about his potential federal estate tax liabilities. He is considering making gifts to his minor grandchildren to reduce the size of his estate. He has four grandchildren, to whom he will make gifts of $25,000 each. This will reduce the size of his estate by $100,000. How much will his gift tax liability be?

Question 5

> Mary is a senior citizen who wishes to maintain her personal and financial independence. In recent years, her health has begun to deteriorate, and she is concerned about confinement to a nursing home and the expense that would be incurred. Should Mary be confined to a nursing home, what choices does she have to maintain her financial independence?

Generally, story questions involve several sentences, most of which are not relevant to the actual question being asked. Usually, only one or two of the sentences is important in arriving at an answer for the test item. Frequently, the actual test point or question is near the end of the long question.

The actual test question, or test item, in the five story questions are as follows:

Question 1: The question is asking you about the offer of one-half of the commission to Paul. It does not refer to Bill's offer or attempt to sell the insurance. In short form, the entire question could be asked as:

An offer by an insurance agent of one-half of the commission to a prospect as part of a sales presentation is an example of what?

Question 2: The question is asking you to identify the penalty involved for an excess contribution to the IRA. Again, the test item could have been worded as follows:

How much is the penalty for an excess IRA contribution?

Question 3: The question is, what will be the price of the new bond as it relates to the decreased interest rate. It could have been worded simply as follows:

When interest rates decrease, what happens to the price of a bond?

Question 4: Obviously, the actual question is, what will Jack's gift tax liability be? However, the sentence that states that each grandchild will receive a gift of $25,000 is important, since this figure tells you the size of the gift from which the gift tax will be computed. The question could have been worded:

If a donor gives $25,000 to a grandchild, how much of this amount is subject to federal gift tax?

Question 5: The question is, basically, what alternatives does Mary have with regard to the expense incurred by a nursing home confinement. The test item could have been stated simply as follows:

What financial resources may be available to pay for nursing home expenses?

Story problems are not difficult—if you can blow away the smoke and find the fire.

Multiple Answer Questions

Very often, this type of test item causes much frustration and anxiety, even for good test takers. This type of question often consists of the test item followed by a series of numbered options, followed in turn by lettered options. Thus, there are twice as many options and distracters. For example:

Stem Which of the following is a function of the U.S Supreme Court?

Options

I Rendering appellate decisions from lower courts.
II Approving cabinet appointments of the president.
III Providing opinions on current social and public issues.
IV Implementing laws on the federal and state level.

Options

A. I only.
B. II and IV.
C. I and III.
D. II, III and IV.

Letter C is the correct response (the key) to this question. Thus, Roman numeral options II and IV, as well as options A, B and D, are all distracters.

Very often, the multiple answer question can be reduced to a true or false test item. For example, you could read the above question on the Supreme Court and, before each option, say:

True or false, rendering appellate decisions from lower courts.

True or false, approving cabinet appointments of the president.

True or false, providing opinions on current social and public issues.

True or false, implementing laws on the federal and state level.

This question doesn't appear as threatening when it is reduced to a true and false test. You will generally feel more comfortable answering this question by playing this little mind game with yourself. As your comfort level increases, so does your confidence.

Naturally, you cannot reduce the multiple answer question to a true and false item all of the time, but this approach works much of the time. For example, read the following test items and identify those in which the responses could be turned into true and false options.

1. Identify the principal causes of World War II.

2. Which of the following are considered elements of a legal contract?

3. The principal parts of a single cell include:

4. Snow is caused by:

5. The differences between a peril and a hazard are that the peril:

Depending on the wording, probably all of the options could be prefaced with true and false. For example, the causes of World War II were (true or false) Japan's capitalism, economic threats to Japan in the Pacific, Germany's invasion of other nations, etc. The elements of a legal contract are (true or false) competent parties, offer and acceptance, etc. The principal parts of a cell are (true or false) protoplasm, the cell membrane, etc. Snow is caused by (true or false) barometric pressure, moisture in the air, etc. A peril (true or false) is the cause of a loss, the result of a hazard, etc.

Another version of the multiple answer test item is one in which you are asked to **rank order** something, such as the following:

Rank order the following bonds according to their maturity, from the shortest to the longest.

I T-bonds.
II T-bills.
III T-notes.

A. I, II and III.
B. II, I and III.
C. III, I and II.
D. II, III and I.

Naturally, to answer this question, you need some knowledge or basic facts. Let's assume, however, that all you are able to recall is the fact that T-bills have the shortest maturity. You may have to take a guess at

this question, but at least you have something to work with. If T-bills have the shortest maturity, based on how the question is asked, T-bills, option II, must be in the first position.

There are only two choices, B and D, which have Roman numeral II in the first position. Therefore, your guess is now reduced to two choices. In other words, this type of question can be worked with even if you do not know all of the information required to answer it.

You can improve your proficiency with this type of question by selecting one or two of the options and using them as option guides in responding to the question. For example:

Option Guides

Which of the following is true regarding the licensing of an insurance agent?

I Prelicensing education requirements must be satisfied.
II The individual must be at least age 18.
III The person must be a United States citizen.
IV A state licensing exam must be passed.

A. III and IV.
B. I, II and III.
C. I, II and IV.
D. I, II, III and IV.

Let's assume that you know with certainty that

Roman numerals I and IV are correct. Your recollection regarding options II and III is not quite as sharp. I and IV then become your option guides. You must select an answer that contains I and IV. This means either C or D. You then decide with a degree of certainty that III is not a correct response. Therefore, you must select an answer that contains I and IV but does not include III. Without any further debate with yourself, you now pick C as the correct answer.

Accordingly, your task is made easier by systematically attacking this type of question and trying to determine option guides. In addition, this question also lends itself to the true-false approach, which can ease your task somewhat.

Preparation + Attack = Solution

With proper preparation and a systematic attack, multiple answer questions are not that difficult. Notice the word *attack* is used here. Be aggressive. Don't be apprehensive. Go after this type of question in a systematic way, and it should be no more difficult than any other type of objective question.

Summary

Objective-type tests generally consist of four main types of questions. The easiest of these is probably the definition question, which asks you to define or describe something. The test item is short and the possible answers usually are brief. Generally, this type of question asks you to recall some memorized fact or concept.

The "except" question causes you to reverse gears and look for an incorrect or untrue answer, which becomes the correct response. Typically, the stem of this question is, "All of the following are true except." You have to remind yourself that you're not attempting to locate a true response, but something that is untrue. You could answer this question by also identifying all of the true or correct responses, which only leaves you with the incorrect option and the right answer.

Story questions require that you blow away the smoke to get to the fire. Often, a story question is long and contains extraneous information. You need to underline what is important in the question. The key to success is making sure you understand what the question is actually asking.

Multiple answer questions may require that you convert the test item into a true and false question and/or identify certain option guides to help you along your journey to the answer. The important thing is not to panic. These types of questions are not as threatening as they may appear.

Regardless of the type of objective question, remember the answers are all there! It's an open-book exam. You simply need to approach this type of exam with the right preparation, attitude and test-taking skills.

14

A Lifelong Adventure

Learning should be a lifelong activity—and adventure.

When we were small children, learning was an adventure of new things, smells, activities and sounds. As children, we were inquisitive, fearless, aggressive learners. This enthusiasm and aggressiveness followed us into the early years of our formal education.

Unfortunately, somewhere along the way, we began to lose the enthusiasm and became passive, reactive learners. We waited to learn until the teacher told us what to do, how to do it and when to do it. Instead of taking the lead and initiative for learning, we became followers of the system, which too frequently told us what to think but not necessarily how to think. Learning became meaningless and boring much of the time.

Things didn't get much better when we entered college. We became student numbers and were frequently forced to attend overcrowded lectures that were not very motivating and seldom permitted any questioning, but were great for catching up on sleep. Learning may have become a negative experience. Finally, we entered the working world by means of graduation and thought that the worst was over.

Now, you've been on the job for several years. Things are moving along, when new words suddenly become part of your everyday vocabulary. These new words are reengineering, downsizing, reorganization and merger. Out with the old employment contract and in with the new.

The new employment contract identifies you as an asset of the company. Maintain your profitability and you may escape downsizing. If you become less profitable, you may be cut. Now the name of the game is how to hang onto your fragile job security.

One way is to continue your education. As a corporate asset, you enhance your worth to the company by attaining new knowledge, new skills and possibly higher formal education. Your lifelong learning adventure continues, but you need certain tools to compete and continue.

Basically, you need to rekindle the enthusiasm and positive attitude of your youth, and then sharpen your learning skills. If you've not used those skills for many years, you will be forced to undertake a skill-rebuilding project and continue your learning if for no other reason than pure economic survival.

The Rejuvenation Process

> **Effective Learning =**
> **Enthusiasm + Attitude + Skills**

This is basically the formula to jump start your adult learning engine. You have to recapture the fun and excitement of learning. Learning does not have to be the chore you closed the doors on many years ago,

when you left college. The joy of learning can be re-kindled.

The key to any success in life is often attitude. Approach a job assignment or a learning endeavor with a positive attitude and you will succeed. Approach the work place or a learning situation with a negative attitude and you may well fail.

The development of the right disposition toward learning begins with understanding how you learn. As very young children, we learned by seeing, hearing and touching. We were visual, auditory and kinesthetic learners. As we grew into adults, we tended to favor one method of learning over another. The formal education process is generally built for auditory and visual learners. But if you are primarily an auditory learner and you are told to study a manual, you may not learn as well, because reading the manual places you in the visual learning mode.

Finally, as a successful adult learner, you need to be adaptive. You must be able to adapt to your learning environment to succeed. If you have to read a manual as opposed to listening to a lecture, you must have the necessary skills to allow you to adapt to this learning situation.

Adapting also requires that you be able to analyze a learning situation and relate it to a previous positive or negative learning experience. You have the capability of learning from either type of situation. You can attempt to repeat a favorable learning experience or take the necessary steps to avoid a negative experience.

Thus, as an adult, it is possible for you to rekindle the learning spark of your youth—to become a sponge

again, and to have the proper disposition toward learning.

Planning Your Trip

Once you are able to approach the adult learning experience with enthusiasm and a positive attitude, you're ready for your lifelong trip. You're ready for your journey into adult learning.

You're going to take several pieces of luggage on this trip. These are the various learning and study skills you will need along the way.

Reading Skills

The ability to comprehend and retain what is read is a critical skill, since so much of adult learning is visual. Your enthusiasm for learning has to spill over into the reading function.

You must read aggressively if you are to comprehend and understand information. It is not enough to stare at a book. You must attack the book. The attack begins with a preview of the reading material.

> **Previewing =**
> **Systematic and Meaningful Browsing**

Previewing is browsing with a purpose. Your purpose is to establish a road map of where you're going. Previewing a reading assignment by reading chapter headings, reading key sentences in paragraphs and paying attention to graphics provides you with a sense of direction—where the reading will take you.

Next, you should grab a pen or highlighter as you begin the actual reading. Get into the habit of underlining topic sentences, key concepts and definitions. Now, you're taking the road map and breaking it down into small bits and pieces.

Once the reading is completed, it is critical to review what you read. Review it the same day you read it. Then keep the new information fresh in your mind by continually reviewing the reading assignment.

Finally, confine your reading to a series of short periods. It is more advantageous to spend four 15-minute periods reading new material, followed by short breaks, than to spend an entire hour staring at the printed word. As adults, we have limited focus and attention spans. Therefore, limit your reading to fit those 15-minute attention spans.

Listening Skills

Another important piece of luggage for your trip is your ability to be an effective listener.

- Hearing is a physical function.

- Listening provides meaning and understanding to what we hear.

- A "good listener" understands and responds to what is heard.

- An effective listener hears, is focused, assimilates and understands information—and responds.

A focused listener is an active listener. A focused listener takes notes based on what is heard, asks questions and is generally involved in the learning activ-

ity. A passive listener simply occupies space and is easily distracted by personal problems and unrelated issues.

Assimilation involves the classification and organization of information so that there is understanding and meaning. This in turn leads to a response from the listener in the form of a smile, a nod, passing an exam or demonstrating a newly learned skill.

You can improve your listening abilities by proper preparation. Before you attend a lecture, preview the topic to be discussed in much the same way that you would preview a book before actually reading it.

Pay attention to the listening environment. Arrive early for the lecture, pick out a seat near the front so that you can see and hear better. Avoid distractions that may occur by sitting near a door or a window.

Check your attitudes and emotions at the door. If you attend a lecture with preconceived notions about the topics or the speaker, you will listen to very little. You'll be too preoccupied with your conflicting personal beliefs or your dislike of the speaker to listen effectively.

Take notes on what you hear. Ask questions. Become involved in the listening and learning process.

Note Taking

Much of what is read or listened to becomes condensed in the form of notes. As an adult learner, it is important that you know how to take notes—that you have the ability to determine what is important and what is not important. The ability to take good notes is like keeping a diary of your trip. You're not going

to record every rest stop on your trip or every meal you had. You will keep the highlights in your diary.

> **Note taking is self-communication.**

Generally, you are the only person who has to read your notes. Therefore, there is no need to use good grammar, spell correctly or write in complete sentences. You simply have to leave a trail of what is important.

To help you with determining importance, you need to prepare. You need to have a general understanding of what you will be taking notes on in advance.

Good listening is usually related to good note taking. If you can listen for the key concepts and important definitions, you should be able to take good notes. Anything that a speaker may write on the board is probably important. Points that are stressed or repeated are usually relevant.

To a degree, speed is an important aspect of note taking. You need to be able to identify the important facts and quickly transcribe this information into a meaningful note. Accordingly, you need to develop your own version of shorthand. Remember, you're normally the only person who has to be able to understand these coded messages.

Math Skills

The ability to work with math is a state of mind. Many people are intimidated and turned off by math. Their minds are closed. However, as an adult learner, math usually will enter your life at some point. Normally, this will be non-threatening, simple math. As an adult learner, you may simply have to fight your mental block when it comes to working with math.

You probably have the ability to learn math (aptitude), but not the proper disposition (attitude). Therefore, the first step is to blot out your residual negative learning experiences and approach your mathematical experience positively.

Listening skills are important. You must stay focused and listen to the mathematical explanation of a problem, for example. You also have to be able to take precise notes regarding a particular mathematical function or problem. Unlike other note taking, you must be exact and precise, since math is an exact science.

Understanding math requires the ability and motivation to continue to practice and drill on the concepts you are trying to learn. Frequently, success with math is based on repetition. You must repeat and practice the same function over and over again. This requires some firm commitment on your part.

Success with math is indeed a state of mind. You must program yourself to do that which you do not like to do. You must possess a certain amount of self-discipline and develop and maintain a positive attitude.

Memory Skills

Another vital piece of luggage necessary for your trip through adult learning is memory.

> **The brain stores information.**
> **Memory recalls stored information.**

Our brains consist of millions and millions of cells, some of which we may lose through age or illness. Nevertheless, our brains continue to be vast reservoirs of information.

Our memory is aided by our ability to connect certain bits and pieces of information stored in our brain. These connections and experiences aid in our recall of information.

Our recall mechanism, memory, is affected by age and experience. However, the ability to recall information is not lost due to age. It simply slows down a bit.

Memory and forgetting go hand in hand, just like peanut butter and jelly. Our short-term memory stores information for short periods of time. We normally lose about 80 percent of this stored information. In other words, it never makes it to our long-term memory bank, and thus long-term recall becomes extremely difficult.

There are certain steps we can take to limit this loss of short-term, as well as long-term, memory. To aid in retention of information in the short-term memory bank, you must immediately review the information. The same day that the information is stored, it is important for you to review your notes or reading. Delay can result in a loss of information.

To aid in memory, you also should pace yourself. Limit your reading or study to short periods of time—about 15 minutes. Short spurts have a more lasting

effect than prolonged periods of study. Pacing yourself permits your brain to store smaller bits of information, which improves memory and retention.

Periodically, you need to review the information. It is important to keep it fresh so that long-term recall is easier. It is not enough to review information one time. It must be continually processed and reprocessed.

Memory can be aided by playing games with yourself. Rhymes, mnemonics, diagrams and pictures all aid in retention. Very often, you can remember pictures and jingles more easily than words and facts.

Your memory also is served well by using as many of your senses as possible. If you can hear it, see it, smell it or touch it, you're more likely to remember it. One-dimensional learning acts as a hindrance to memory.

Test-Taking Skills

The ultimate measure of whether learning has taken place is often the dreaded test. The trauma of test taking planted its roots early in your formal education by means of parental, teacher and peer approval or disapproval. In spite of your current feelings about test taking, developing and maintaining a positive attitude usually will get you through the testing ordeal.

Belief in failure produces failure.
Belief in success produces success.

If you approach a test with the attitude that you'll fail, chances are you will fail. You will simply reinforce your negative attitude. A positive approach to test taking will usually produce positive results.

In addition to a positive attitude, you also have to sharpen your test-taking skills. There are certain basic skills or techniques that you need to have, regardless of the type of test you're taking. These basic test-taking techniques include:

- Proper preparation prior to testing. You must study and review the material on which you're to be tested.

- Scan the test first by browsing through the test content in order to get a feel for the types of questions being asked and timing necessary to complete the test.

- Always read the full question very carefully for understanding, and then proceed to read all of the answers.

- First answer those questions that you feel most confident about, and then address the remaining questions.

- Once you select an answer for a question, usually you should not change it. Normally, your first thought (or guess) is your best choice.

Occasionally, you may have to take an essay test. In answering essay questions, you need the ability to write a response that is concise and to the point of the question being asked. This means that you should begin your answer with a topic sentence, followed by additional sentences that support the topic of your paragraph. Avoid rambling and writing solely for the purpose of filling up space. Stay connected.

True or False

True or false tests should be prepared for in the same way as any other test. Basic test-taking techniques need to be applied to this type of test. In addition, you should be aware of certain clue words, such as "only," "always," "never," etc. When these words appear in a true or false test, most often the answer is *false*. As is true with any test, careful reading of the question or test item is essential. This is possibly more important with a true-false test.

Matching tests require the same approach and techniques.

Multiple Choice Exam

The predominant type of objective test given to adult learners is the multiple choice exam. Success with this type of exam begins with preparation, review and study, and the use of basic test-taking techniques. There are four basic types of test items:

The **definition** item is usually a short, simple question and answer format. These are the "easy" questions.

The **except** item forces you to find a false or incorrect response—"All of the following are true except ..." You have to say to yourself that you're looking for an incorrect, not a correct, response.

The **story** question takes a concept and "hides" it in a short scenario. This type of question requires that you be able to find the important information and pay little or no attention to the irrelevant data. You have

to be able to blow away the smoke to find the fire.

The **multiple answer** question is a long, sometimes complicated test item. These complexities often can be reduced to simple terms by converting the options into true-false items. In addition, by careful reading of the question, you can reduce your choice of answers by eliminating certain distractors. This process can help to reduce the complexity of this type of question.

Test taking should not be a major trauma if you approach the task positively, use basic test-taking techniques and use specific skills depending on the type of question being asked.

**Test-Taking Success =
Attitude + Testing Skills + Techniques**

Duration of Your Trip

As an adult learner, your trip will never end. Learning should be a lifelong process, not just a short stop during the period of your formal education.

In today's workplace, you need to constantly seek out new ways and opportunities to acquire new skills and knowledge. This will provide self-improvement, as well as enhancing your value as a "work asset." Your continued growth through education and learning places you at a competitive advantage over your peers, and is necessary for survival in the workplace today.

Job security is based on what you know or can learn—it is not simply doing your job and being a "good

employee." New technology, global competition and cost-cutting reorganizations require your continued learning for survival.

Equally as important, you owe it to yourself to be a lifelong learner. Personally, your life will be better because you are a continuous learner. The adult learner is happier, more vibrant and sharper than the non-learner.

Atrophy can affect your muscles and physical activities. Mental atrophy occurs when you stop learning and using your talents and abilities. Learning should not be viewed as a chore. It should be exciting and fun. It should be a joy.

If you carefully read the words of Eric Hoffer, you will understand the value of learning and education:

> "In times of change, learners inherit the earth, while the unlearned find themselves beautifully equipped to deal with a world that no longer exists."

Exercises

A number of exercises have appeared throughout the book. Some were designed to identify your learning profile and your strengths and weaknesses. Others were designed to help you hone your skills. We've brought them together here as a handy review section.

You may want to refer back to these exercises from time to time, as a quick refresher course. Keeping all of your responses in a notebook also will give you a chance to look back at previous practice runs, which is a great way to build confidence, since it enables you to prove to yourself just how far you've come.

Learning Profile Survey

Grab a notebook and a pen or pencil and record whether each of the following statements is true or false for you, to reflect how you feel you learn best. Answer each statement as it would apply or not apply to you as a general rule.

1. I learned more in physical education class than I did in history class.

2. My retention is better if I can see new information in charts, diagrams and graphics.

3. I learn a lot from small group discussions.

4. I would prefer hiking in the woods to reading about it in a library.

5. I learn best by attending lectures and listening to knowledgeable instructors.

6. Watching a video is an ideal way for me to learn a new skill.

7. I would rather read a book about gardening and flowers than actually plant a garden.

8. I can solve problems by trial and error.

9. I can attend a lecture and remember most of what was said without the aid of notes.

10. I seem to learn best from books and manuals.

11. I enjoyed such classes as science lab, typing and shop.

12. Audio tapes are a more effective learning tool for me than videotapes.

13. I understand Beethoven because I enjoy listening to his music.

14. I have no trouble reading maps.

15. I don't need instructions to assemble a model airplane.

This short survey is not designed to scientifically identify your learning profile with 100 percent accuracy, but it does provide an indication of how you might normally learn best. Basically, this quiz attempts to determine if you learn best by seeing it, by hearing it or by touching and doing it. Are you primarily a visual learner, an auditory learner or a kinesthetic learner?

True responses to questions 2, 6, 7, 10 and 14 indicate a **visual learner**. You are a person who seems to learn well by reading, spending time in a library, using videotapes, etc.

True responses to questions 3, 5, 9, 12 and 13 are representative of the **auditory learner**. You get more out of learning when you hear it, as opposed to reading about it. You spend more time attending lectures or listening to tapes than reading or going to the library.

True responses to questions 1, 4, 8, 11 and 15 would identify you as a doer. You are a **kinesthetic learner**. You learn by touching it, physically working with it (as opposed to reading about it) or attending a lecture. At Christmas, you're the person who doesn't bother to read the assembly instructions for a child's toy. You just rip open the box, pull out 101 pieces and proceed

(often by trial and error) to assemble the toy.

So, for example, if you had five true responses for the visual learning statements, two true responses for the auditory statements and one for the kinesthetic, you probably learn best through your sense of vision. Accordingly, if you are forced to listen to a lecture for an hour, you may not get as much out of that learning experience as you would if you had the opportunity to read and study the lecture notes.

Learning Experience Survey

1. What type of learner are you (auditory, visual, kinesthetic)?

2. Describe a learning experience in your past that you really feel positive about, including whether it was a formal educational experience, job-related experience, learning a hobby, etc.

3. What was your motivation for becoming involved in this learning situation?

4. How much time did you spend in this learning situation?

5. How did you feel about this learning situation:
 a. Before you became involved in it?
 b. During the learning experience?
 c. At the conclusion of the learning situation?

6. Did you receive any help or assistance during this learning activity?
 a. If so, from whom?
 b. How valuable or positive was this assistance?

7. What did you enjoy most about this learning experience?

8. What did you enjoy least about this experience?

9. What value does this learning experience have in your life today?

10. In retrospect, is there anything about this learning experience that you would change today?

What you now need to do is take the positives from

this past learning situation and attempt to adapt them to a present-day learning activity.

Listening Survey

Grab your notebook again and write down T for True if you feel the statement describes your listening attitude or behavior. Write F for False if the statement is not descriptive of your listening behavior.

1. Generally, I control my emotions when listening to a speaker.

2. I have little difficulty paying attention to a speaker's message.

3. I always ask some questions during a lecture or training session.

4. I usually take notes during a speaker's presentation.

5. I do not get upset if a speaker's opinions are different from my own.

6. I make good eye contact with a speaker most of the time.

7. I am not easily distracted when listening to most speakers.

8. I evaluate the information given by a speaker, not the speaker himself or herself.

9. Understanding the key points of a verbal presentation is not difficult for me.

10. I respond throughout a speaker's presentation by occasionally nodding my head or smiling to reflect my agreement.

11. It is not difficult to listen to a speaker who is considerably younger than I am.

12. I listen between the lines of a presentation to identify the speaker's emotional message.

13. Prior negative learning experiences do not affect my ability to listen to a speaker.

14. The speaker's delivery and style are not as important as the message.

15. Good listening habits are related to good posture.

If you had 14 to 15 true responses, you should write a book on effective listening habits!

A score of 12 to 13 true responses generally means you're a good listener.

A score of 10 to 11 true responses means you're probably an average listener, but there is certainly room for improvement.

Fewer than 10 true responses indicates you definitely need to sharpen your listening skills.

Distraction Checklist

Using this 1-to-5 scale, rate each of the following situations on its ability to distract you.

$$\xrightarrow{\hspace{8cm}}$$

1	2	3	4	5
Minimum Distraction		Moderate Distraction		Major Distraction

1. Internal personal problems that affect concentration.

2. A prior negative experience with the speaker.

3. A speaker with a heavy foreign or regional accent.

4. A noisy environment.

5. A speaking topic that is of little interest to you.

6. An extremely pleasant-looking speaker.

7. An extremely unpleasant-looking speaker.

9. An uncomfortable room—too hot, too cold, poor lighting, etc.

10. A speaker or speech that is poorly organized.

11. Exhaustion and fatigue.

12. Bad time—too early in the morning, too late in the day.

13. A speaker who causes anxiety or apprehension.

14. A speech that is contrary to your attitudes and beliefs.

15. The use of profanity or vulgarity by the speaker.

Needless to say, this list of distractions could be expanded. However, it is useful in identifying the type of situations that you find very distracting.

The trick now is to avoid these distractions, or find another way to keep them from detracting from a learning experience.

A Test Quiz

Here's a quick test to determine your attitude and feelings toward testing.

Read each statement. If it applies to you, record a T for True in your notebook. If it doesn't apply to you, write an F for False.

1. I usually feel fatigued when taking a test.

2. I am one of the last ones to finish a test.

3. I can't eat before I take a test.

4. I don't score as well on tests as I should.

5. During a test, I often forget the material I studied to prepare for the test.

6. It is difficult for me to stay focused when taking an exam.

7. I'd be perfectly happy if I never had to take another test again.

8. Tests serve no real purpose for anyone.

9. I would rather take an oral test than a written test.

10. I normally feel embarrassed by my test scores.

All of us experience some apprehension when taking an exam, but if you answered "true" seven or more times, you probably have an anxiety attack every time you take a test.

The best way to handle this kind of response is to work on your concentration. And, of course, you'll want to practice all the test-taking techniques in this book, so you'll feel more confident going into an exam.

Writing Sample Test Questions

If a reading assignment will lead to an exam, it's a good idea to jot down possible test questions as you read. This will aid in your retention. Here's a chance to practice this technique. Read the following paragraphs, paying particular attention to topic sentences and definitions. After you read each paragraph, write down two or three sample test questions based on it. (For an analysis of these paragraphs, see page 51.)

Paragraph 1

> Medicare is a federal program of health care for the aged and the disabled. Aged means attainment of age 65. Disabled refers to those who have collected Social Security disability benefits for at least 24 months and those who have serious kidney problems resulting in dialysis treatment for at least three months. Medicare is administered by the Health Care Financing Administration through various Social Security offices throughout the country.

Paragraph 2

> Medicare consists of two parts—Part A and Part B. Part A is hospital insurance and primarily covers inpatient expenses incurred while hospitalized. Types of covered expenses include hospital room and board, general nursing services and inpatient physical therapy. Attainment of age 65 and prior

payment of the Medicare tax (as part of the total Social Security tax) qualify a person for Part A benefits. Thus, it is an automatic benefit that has been prepaid through your taxes while you were employed.

Part B of Medicare covers outpatient expenses and the expenses associated with the services of physicians and surgeons. Part B is also known as medical insurance. Unlike Part A, Part B is not automatic. You must enroll in Part B and begin paying a monthly premium for these benefits. This enrollment generally takes place at age 65, at the same time you achieve eligibility for Part A benefits. Types of benefits provided by Part B include outpatient therapy, doctor's office calls, surgeon's fees and diagnostic services.

Paragraph 3

Note-Taking Exercise

Here's a chance to practice identifying the important points in a paragraph, particularly as they apply to the test or discussion situation you will be faced with. Read the instructions, then read each paragraph. After you read a paragraph, take the appropriate notes. (This may or may not include the topic sentence in the paragraph.) Feel free to abbreviate or use your own shorthand.

Paragraph 1

You are listening to a panel discussion regarding the presidency of Abraham Lincoln as part of an American history course you are taking. You eventually will participate in an open discussion of the 16th president of the United States, based on the panel's discussion.

> The Civil War began when Fort Sumter was fired on by Confederate troops in the spring of 1861. Fort Sumter is situated in the harbor of Charleston, South Carolina, where it remains today as a national monument. When the war ended in April 1865, a tribute to both the North and the South was planned for Fort Sumter. A prominent northern politician was invited to these ceremonies, but had to decline the invitation because he and his wife were to attend a play at Ford's Theater in Washington, D.C. Abraham Lincoln sent a representative in his place to Fort Sumter and attended Ford's Theater instead. Had President Lin-

coln attended the ceremonies at Fort Sumter, perhaps the history of the post–Civil War South would have been different.

You are preparing for your final exam covering the history of the Civil War by attending the last class of the semester, two days before your test.

Paragraph 2

The cause of the Civil War was economic. The North threatened the abolishment of slavery. The South viewed this movement as an attempt to destroy their economic way of life and their very culture. Doing away with slavery would bring economic ruin to the South, as an entire institution would be destroyed and, in the process, a way of life and living also would be destroyed. The South's economic survival was at risk. Attempts at political compromise had not worked. Finally, the election of Abraham Lincoln as the 16th president of the United States was the final insult. In the spring of 1861, Confederate troops opened fire on Fort Sumter in Charleston harbor. Thus began the bloodiest war in American history.

Shorthand Exercise

When taking notes from a speaker, speed is essential. Therefore, you'll want to practice developing your own shorthand, so you can get important information down on paper without missing whatever follows. (Do remember to review your notes soon after the lecture or seminar, though, so you can spell out any shorthand references while you still remember what they mean.)

Here are a few sample items for you to practice with. If you'd like to make the note-taking situation even more realistic, you may want to dictate these paragraphs into a tape recorder, then take notes from your playback. (For examples of how you might take notes on this information, turn to page 100.)

1. The computer terminals must be turned off every evening at 6 o'clock.

2. The cost of your hospitalization insurance will be reduced by increasing the deductible.

3. The last war the United States was involved in was World War II. Since then, the other conflicts might be called acts of war.

4. The government may increase Social Security benefits by means of increased Social Security taxes. Increased taxes are an important consideration for every senior citizen

5. People buy life insurance to protect against the risk of premature death. They purchase annuities to protect against the risk of living too long. It is esti-

mated that by the year 2045, there will be more than 1 million people age 100 or older. We are living longer due to medical advances and healthier lifestyles. For example, fewer people smoke today and, generally, all of us are diet- and exercise-conscious.

Story Questions

When it comes to so-called story questions, you need to "blow away the smoke" to find the question hidden within the story. To practice this technique, read the following story questions, noting the key information. Then jot down the much shorter question that was hidden within the story.

Question 1

Five years ago, Charlie purchased 100 shares of the ABC Mutual Fund at a price of $10 per share. Charlie felt that he could double his investment over five years. Due to a medical emergency, he is now being forced to redeem these 100 shares. The current purchase price is $11.50 per share and the current redemption price is $11 per share. How much will Charlie lose or gain if he redeems the 100 shares today?

Question 2

Mary has $1. She has been instructed to go to the store and buy pencils. If each pencil costs 10 cents, how many pencils can Mary buy?

Question 3

Bill has been attempting to sell Paul some life insurance. He has tried every closing technique he

knows, but Paul is reluctant to sign the application and buy the insurance. Finally, Bill offers Paul one-half of the commission if Paul will sign the application at once. This offer is an example of what?

Question 4

Karen works for Acme Inc. and is not a participant in the company pension plan. Karen maintains an Individual Retirement Account (IRA) and has made the maximum $2,000 annual contribution permitted by law to the account for many years. This year, she made a contribution of $2,500. This is an excess contribution subject to a penalty by the IRS. How much will she be penalized?

Question 5

An investor purchased a bond from the Acme Corp. many years ago. The bond has paid 10 percent interest for the past 20 years, but will mature in two weeks. The investor has decided to reinvest in another Acme bond at maturity. However, the interest rate to be paid on the new bond is only 6 percent. Since interest rates have fallen, the price of the new bond will be _____.

Question 6

Jack is concerned about his potential federal estate tax liabilities. He is considering making gifts to his minor grandchildren to reduce the size of his estate. He has four grandchildren, to whom he will make gifts of $25,000 each. This will reduce the size of his estate by $100,000. How much will his gift tax liability be?

Question 7

Mary is a senior citizen who wishes to maintain her personal and financial independence. In recent years, her health has begun to deteriorate, and she is concerned about confinement to a nursing home and the expense that would be incurred. Should Mary be confined to a nursing home, what choices does she have to maintain her financial independence?

A Matching Test in Progress

Matching tests are seldom used in adult learning situations, but the techniques used to answer them can come in handy in other sorts of tests, especially the ubiquitous multiple choice test.

In this case, we'll consider a test in progress. Because this test has longer statements in Column A, remember that you'll want to work with these entries and try to match them to the shorter choices in Column B. As always, you should answer the questions you're sure of right away, then go back and use deductive reasoning to answer the "hard ones."

Let's assume that you've already matched all the easy ones. Now you're ready to get analytical. Even if you don't know the answers to these questions, you should be able to make pretty good guesses. (To see how you've done, turn to page 166.)

	Column A		Column B
C	1. Health-care benefits for the financially needy.		A. $736
G	2. Hospital insurance under Medicare.	✔	B. A Medicare supplement
L	3. Health-care benefits for the aged and the disabled.	✔	C. Medicaid
			D. 90 days
J	4. This part of Medicare covers doctor's charges and out-patient expenses.	✔	E. Hospice care
			F. $100
B	5. This product is designed to fill the gaps left by Medicare.	✔	G. Part A
		✔	H. Skilled nursing care
E	6. A voluntary program that provides pain control and treatment for the care of the terminally ill.		I. 60 days
		✔	J. Part B
			K. Social Security
H	7. Twenty-four hour a day care provided in a nursing home under the supervision of a medical doctor.	✔	L. Medicare
___	8. A benefit period under Part A of Medicare.		
___	9. The number of lifetime reserve days under Part A of Medicare.		
___	10. The Medicare Part B deductible.		

Index

aptitude 12, 107-108, 112, 200
assimilation 69, 73, 76, 89, 198
attitudes and beliefs 77, 80, 216
auditory learner 17-18, 30, 59, 118, 195, 209
classroom situations 7, 36, 38, 91
definition question 179, 190
 distracters 178, 186
 except question 180
 key 178, 186
 multiple answer questions 186-187, 190-191, 205
 option guide 189-191
 options 178, 180, 186-190, 205
 stem 178, 180, 186, 191
 story question 182, 184, 191, 204, 224
distraction checklist 77, 215
effective learning 10, 16, 41, 44, 52, 145, 194, 208
essay tests 147-159, 161, 203
 compare and contrast 153, 158
 evaluation 140-141, 145
 outline 75, 97, 129, 155-156, 158-159
 topic sentence 46-49, 51, 53, 93-94, 149, 151, 156, 158, 197, 203, 218, 220
exhaustion and fatigue 77, 80, 215
focus 3, 28, 45, 63, 67, 69, 76, 78-79, 84, 89, 96, 147, 166, 197
group study 34
grouping 122-123
hands-on learning 37
hearing 11, 17, 19-20, 59-61, 63, 67, 75, 82, 106, 117-118, 195, 197, 209
kinesthetic learner 17, 19, 21, 36-37, 61, 195, 209
learning experience survey 29, 211
learning profile survey 15, 208
listening environment 79, 198
listening process 85-86